IMAGES
*of America*

# OREGON CITY

D1616791

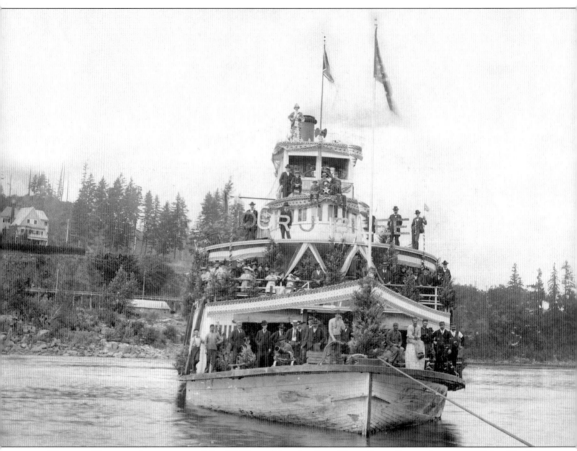

Oregon City was incorporated in 1845, making it the oldest American city west of the Rocky Mountains. In 1895, residents celebrated their 50-year jubilee. The steamboat *Elmore* was decorated for this event. Oregon City claims a long list of firsts and has been celebrating them for a century and a half.

**ON THE COVER:** Oregon City held a summer festival every year from the 1920s until the present day. Called Frontier Days, Territorial Days, Riverfest, or Eelfest, these events bring the people of the area together for picnics, games, races (including steamboat races), a rodeo, and parades. This photograph shows a women's marching team in the Territorial Days parade of 1936.

IMAGES
*of America*

# OREGON CITY

Jim Tompkins

ARCADIA
PUBLISHING

Published by Arcadia Publishing
Charleston SC, Chicago IL, Portsmouth NH, San Francisco CA

Printed in the United States of America

Library of Congress Catalog Card Number: 2006930227

For all general information contact Arcadia Publishing at:
Telephone 843-853-2070
Fax 843-853-0044
E-mail sales@arcadiapublishing.com
For customer service and orders:
Toll-Free 1-888-313-2665

Visit us on the Internet at www.arcadiapublishing.com

*To all of the people of Oregon City, past and present, for making it
the great place it has become and especially to Mayor Alice Norris for
injecting a pride in Oregon City's long history.*

# CONTENTS

Acknowledgments                                           6

Introduction                                              7

1.   Dr. McLoughlin's Land Claim                          9

2.   Business and Industry at the Falls                  23

3.   Willamette River Navigation                         47

4.   Railroads, Trolleys, and Streetcars                 59

5.   Land Transportation Hub                             75

6.   Entertainment and Recreation                        95

7.   Clackamas County Cultural Center                   117

# ACKNOWLEDGMENTS

The Clackamas County Historical Society's (CCHS) collection of photographs is a testament to the photographers who have been capturing images of Oregon City as long as there have been cameras here to record them. Lorenzo Lorain, a U.S. Army lieutenant passing through with a handmade camera in 1857, made the first outdoor photographs of the city. A long list of local photographers includes Carl Moline, Ralph Eddy, and Josie Barnett, whose collections make up a great portion of the nearly 10,000 images in the CCHS collection.

Credit also goes to the people who gathered the photographs that made up the collection. William Howell amassed hundreds of images and had them made into postcards for sale in his drugstore. In the current era, Wilmer Gardner, as curator of the historical society, collected more than half of the total number.

Credit needs to be given to collections curators past and present, to Patrick Harris, former executive director, and Charlene Buckley, the current curator. Also helpful when sorting images have been Betty Caldwell, collections chief, and Beverly Erickson, society volunteer and collections expert.

This book would not have been possible without permission to use the photographs, obtained from Clackamas Heritage Partners.

# INTRODUCTION

They came over 3,000 years ago to settle at the falls. For the next three millennia, they continued to come. By canoe, on foot, or horseback, they came to fish the falls or to explore. They came by ship to trade, by mule train to bring the word of God, and by covered wagon to settle. They developed a city at Willamette Falls.

The settlement at Willamette Falls has seen much change over the last 3,000 years. These transformations can be expected when people come from many different nations, speak many different tongues, believe in many different forms of God, and have differing levels of technology. Some of these transformations were planned, but much of it just evolved. And as with most change, a majority were willing to adapt, but others would still fight it.

Oregon City, the city at Willamette Falls, was once an American Indian fishing community that attracted other Indians from as far away as Alaska, California, and the Great Plains. Oregon City has been a trade center for furs, flour, woolens, electricity, paper products, and supplies needed by settlers. It has also been a gathering place for religious congregations that are the oldest west of the Rocky Mountains for most denominations. In terms of transportation, Oregon City has been a hub for river, rail, and highway traffic, sitting at the entrance to the great Willamette River Valley.

The city has been a political capital for the independent Oregon Country and the American Oregon Territory. It has seen its fair share of accomplishments and disasters and of prosperous times and bust periods. Home to a diverse culture, Oregon City's influential citizens include social, civic, and religious leaders; merchants and industrialists; poets and teachers; and many others.

Willamette Falls, as well as the bluffs and hills of Oregon City, were created by the accumulation of up to 37 layers of basalt, laid down by eruptions of various volcanoes. Several times the Willamette River was blocked at this point and the area south of Oregon City has been a gigantic lake. Once these waters broke over the top, they immediately started eroding the rock.

The American Indians who created the petroglyphs at Black Point also gave the river and the falls their names. Located above the falls were Kalapuyan Indians who called themselves Wal-lamt. The Chinook, located below the falls, called them Tyee Hyas Tumwater. In years that the fishing was good, the banks of the Willamette River would be crowded with tipis and long houses. Women would fill drying racks with salmon, eel, or sturgeon, while old men and children repaired the long-handled nets or the three-tined spears. This way of life evolved for about 3,000 years with little interference.

Starting in the early 19th century, British and American fur traders came to Oregon with the British Northwest Fur Company, arriving in 1811. They soon came to Willamette Falls, and in 1815, Nor'wester Alexander Ross signed a treaty of safe passage around Willamette Falls for his company. The Indians were there to fish, but they knew that the whites wanted furs and that they could barter them for fish hooks, beads, cloth, tobacco, and even guns and whiskey. When

the Hudson's Bay Company absorbed the Northwest Company, they established a trading post at Willamette Falls. It was an obvious site for trade.

Since the boundary between the United States and Canada had not been extended beyond the Rocky Mountains, the powerful Hudson's Bay Company saw the political need to expand as far south into the Oregon Country as possible as a hedge against the future resolution of the joint occupation of Oregon. In 1829, Dr. John McLoughlin, chief factor of the Hudson's Bay Company Columbia Department, laid claim to the land from Willamette Falls to the Clackamas River by having built three log houses on an island in the falls.

The American Indians, resenting this infringement of their land, promptly burned the cabins. But in the minds of the whites, a claim had been made. McLoughlin persisted and, in 1832, built a sawmill. He blasted a millrace to provide power to run the saws. Later the millrace powered the grindstones for his new gristmill.

Americans started arriving in small numbers throughout the 1830s. Among them were missionaries representing American Protestant churches. The Methodist-Episcopal Church sent Jason Lee to Oregon in 1834. McLoughlin convinced him to go to the Willamette Valley, but Lee had a rough start and had to call for reinforcements. The Great Reinforcement of 1840, on the ship *Lausanne*, had a direct impact on the Willamette Falls community. On board were Methodist missionary Alvin Waller and lay steward George Abernethy. Under Lee's direction, they established the Willamette Falls mission on property claimed by McLoughlin. Reverend Waller started a church for the mission in Oregon City.

The job of wresting McLoughlin's claim fell to Abernethy. In 1841, he built a mill on McLoughlin's Mill Island in the falls using McLoughlin's millrace. Thus began a long-lasting feud between Methodists, calling themselves "ultra-Americans," and the British. McLoughlin had been an absentee owner of the property until 1842, when he built a cabin, planted a field of potatoes, and established residency by rules acceptable to Americans.

To keep one step ahead, McLoughlin had his claim redesigned to conform to American custom and had it renamed, surveyed, and platted. Previously known as Willamette Falls, the town was now Oregon City. Sidney Moss, an American who arrived with the Oregon Trail migration that year, was hired by McLoughlin to survey and plat the new city that ran from the falls to Fifteenth Street and from the river to Jackson Street. But the effort to keep the area British was too late. The tide of Americans was about to overwhelm McLoughlin.

It started as a trickle with less than two dozen residents in 1841 that grew to almost 200 in 1842. Then in the spring of 1843, over 800 men, women, and children; 100 covered wagons; and thousands of head of livestock set out from Independence, Missouri, along what would be called the Oregon Trail. Oregon City became the end of this migration. Over the years, at least 350,000 such pioneers made the 2,000-mile trek.

When the United States made Oregon a territory, it passed legislation allowing immigrants to claim up to one square mile of the Oregon Country. To file their claims, immigrants had to come to the Government Land Office in Oregon City. In 1843, the settlers of Oregon established an independent government. The provision was that it would last only until the United States extended its authority over Oregon. Oregon City was made capital of the new, temporary country. The governor from 1845 to 1849 was the Methodist steward George Abernethy. Territorial status arrived in 1849 and Gov. Joe Lane continued Oregon City as the capital. In 1853, in a bold move by rogue Democrats continuing the feud with McLoughlin, the capital was moved to Salem.

For over 3,000 years, the city at the Willamette Falls has seen change with its people, their lifestyles, the kinds of occupations they have had, as well as their power, wealth, and influence. Yet one constant endures—the city of Oregon City, the city at Willamette Falls.

*One*

# DR. MCLOUGHLIN'S LAND CLAIM

For three millennia, people have been gathering at Willamette Falls to fish. Two Indian nations had villages at the mighty Tyee Hyas Tumwater (Chinook jargon for Chief Great Falling Water). Above the falls was a group called the Kalapuya. During the twice-yearly migration of the salmon, other Kalapuya would join the resident Wal-lamts.

Below the falls were the Chinookan Indians. This once mighty nation included the Clackamas, who had their village along the Clackamas River. The Multnomah Indians had a permanent fishing village where the waters of the Willamette River were channeled through Clackamas Rapids.

Regularly joining the resident Kalapuya and Chinook Indians were the Molalla Indians, arriving on horseback from the Cascade Mountains. The mouth of the Clackamas River became a gathering place for visiting American Indians from the Oregon coast, Puget Sound, inland plateaus, Great Plains, California, and Alaska.

Since the beginning of the 19th century, a small number of white fur traders joined the American Indians at the falls. Earlier they had come only to coastal villages, and the great inland fishing centers at Willamette Falls and Celilo Falls were of little interest. Lewis and Clark came within 15 miles of Willamette Falls in 1806 on their trip home.

In 1815, the Northwest Fur Company signed a treaty of safe passage around Willamette Falls. The American Indians were there to fish, but they knew that the whites wanted furs and that they could barter them for fishhooks and other goods. The Hudson's Bay Company saw the need to expand as far south into the Oregon Country as possible. In the winter of 1829–1830, Dr. John McLoughlin, chief factor of the Hudson's Bay Company Columbia Department, laid claim to the land from Willamette Falls to the Clackamas River.

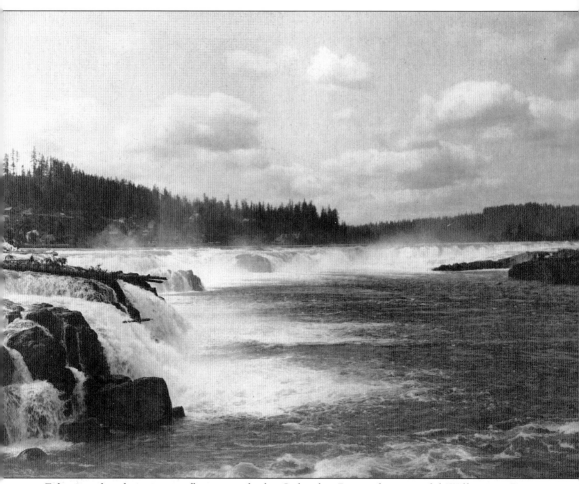

Fifteen miles above its confluence with the Columbia River, the powerful Willamette River drops 31 feet over Willamette Falls. Three dozen layers of volcanic basalt block the river. Lying just below the falls, Oregon City has always been a trading center, serving American Indians from all over the Pacific Northwest, fur traders, early missionaries, and Oregon Trail emigrants. Traffic at Oregon City has included canoes, sailing ships, steamboats, covered wagons, horse carts, railroads, and rubber-tired vehicles. The people of Oregon City have been businessmen, industrialists, politicians, and lawyers related to Oregon City's role in trade, as capital of Oregon, and as the county seat of Clackamas County.

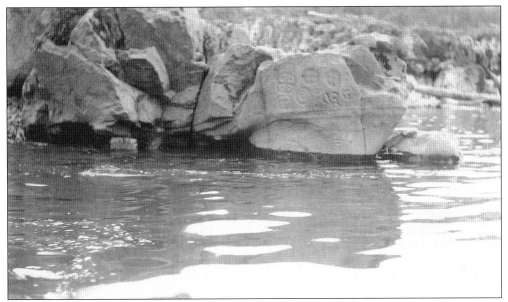

Willamette Falls has seen considerable change over the 3,000 years of human habitation nearby. The falls have been cut up for fish ladders, hydroelectric facilities, a steamboat dry dock, millraces, and mill buildings. Yet after years of improvements, traces of Oregon City's earliest inhabitants can still be seen. Chinook Indians probably created these petroglyphs over 1,000 years ago.

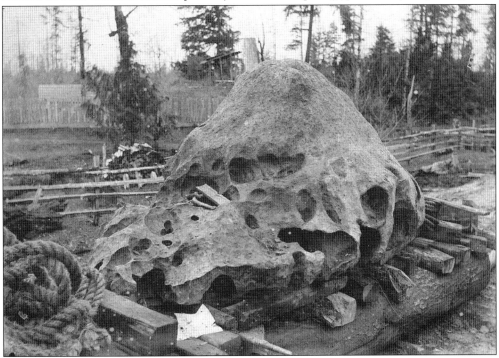

The largest meteorite yet discovered arrived at the future site of Willamette Falls about a million years ago. Ice rafts during the Missoula floods carried rocks from Montana to the Willamette Valley. Discovered in 1903 near Willamette Falls, the Willamette Meteorite was moved to the Lewis and Clark Exposition in 1905. Today it is in a New York City museum.

11

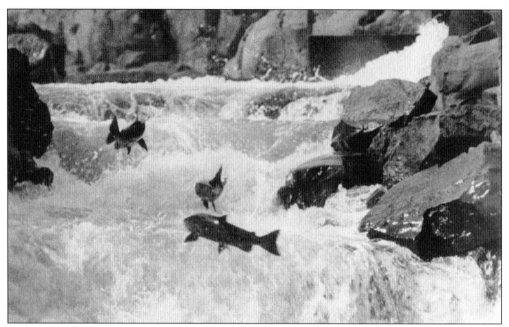

Twice a year, in the spring and fall, Chinook salmon migrate up the Willamette River to their spawning grounds. In addition to salmon jumping the falls, lamprey eel can be seen climbing the rocks, and prehistoric-looking sturgeon are found in deep basins below the falls. This barrier to river navigation makes Willamette Falls a world-class fishing location.

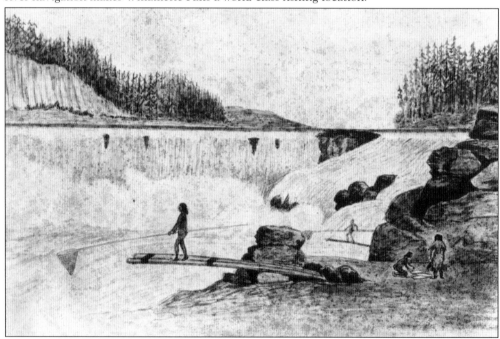

This sketch by an American naval officer with the Wilkes Expedition shows American Indians standing out over the falls on springboards or platforms. Indians caught salmon with long-handled dip nets or three-pronged spears. While the men fished, the women dried and smoked the fish. Elders and children would repair the equipment.

Two permanent Indian villages were at Willamette Falls, with Wal-lamt above and Clackamas below. During the two fish runs each year, locals were joined by thousands of visiting American Indians. Kalapuya occupied Canemah and Multnomah Chinook stayed at this village below the falls. Other American Indians visiting from around the West stayed at a large encampment at Green Point at the mouth of the Clackamas River.

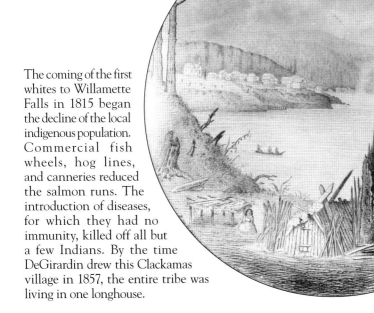

The coming of the first whites to Willamette Falls in 1815 began the decline of the local indigenous population. Commercial fish wheels, hog lines, and canneries reduced the salmon runs. The introduction of diseases, for which they had no immunity, killed off all but a few Indians. By the time DeGirardin drew this Clackamas village in 1857, the entire tribe was living in one longhouse.

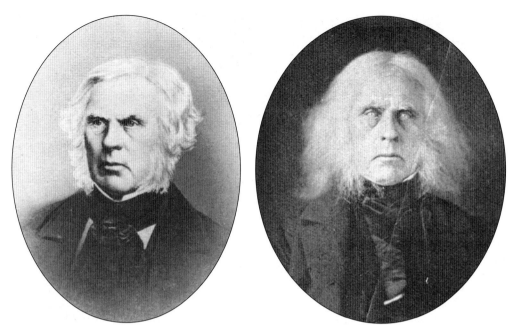

Born in French-speaking Quebec of Scottish and Irish parents and trained as a medical doctor, Dr. John McLoughlin rose among the Northwest Fur Company ranks to chief factor. As a result of a merger, he joined the Hudson's Bay Company and was assigned to the Columbia Department. He ruled from Fort Vancouver with an iron hand but with compassion. In 1829, he claimed Willamette Falls.

In the 1830s, a town grew up on McLoughlin's claim. With the arrival of ultra-American Methodist missionaries, McLoughlin, a British subject, was forced to adopt American standards for property that was clearly going to be in the United States. In 1840, Oregon City was platted and in 1845 incorporated as the oldest American city in the West.

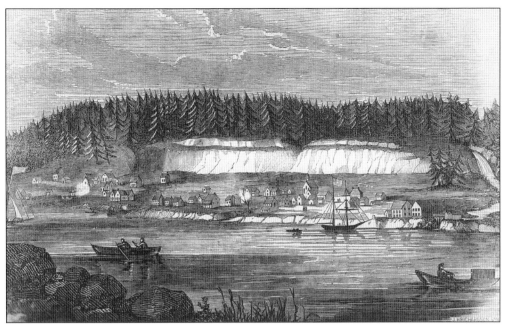

By the time J. H. Richardson drew this sketch of Oregon City in 1845, published in 1849 in *Holden's Dollar Magazine*, the town had two churches, a business, a warehouse district on the edge of the falls, and regular ship traffic from New England to supply the stores. Dr. McLoughlin's retirement house is the tall building right of the American ship flag.

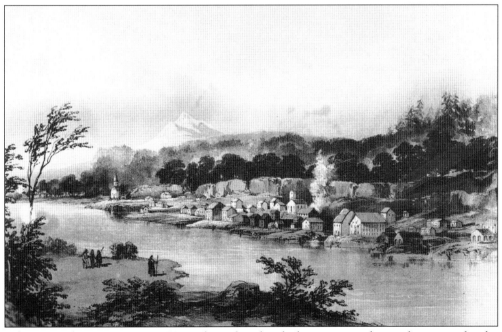

When British spy Lt. Henry Warre drew this sketch, he was providing information for the negotiations of the boundary between the United States and Canada. Dr. McLoughlin was an honored citizen of the city that was officially in the United States the next year. The entire city was on the river level with Mount Hood off to the east.

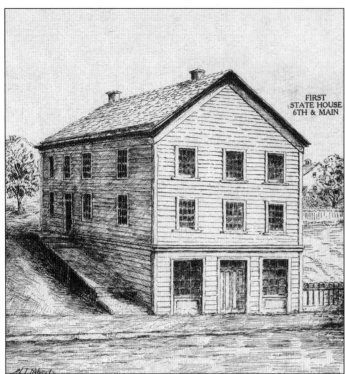

FIRST
STATE HOUSE
6TH & MAIN

Six years before the United States finally created the Oregon Territory in 1849, local Americans created an independent Oregon Country. Oregon City was its first and only capital city. George Abernethy, formerly with the Methodist mission, was governor. This structure was erected in 1849 to serve as the capitol building. By 1853, the government was in Salem and the statehouse became the Oriental Hotel.

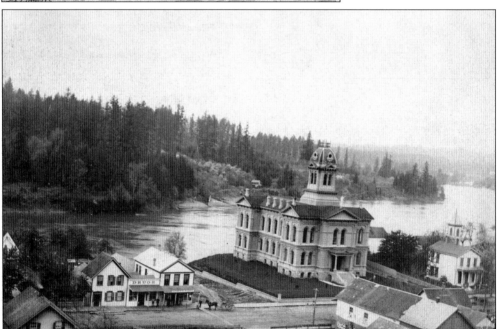

The government of the Oregon Country created four counties in 1843. Clackamas County originally extended from Oregon City east to the Rocky Mountains and north to the Arctic. Portions of Oregon, Washington, Idaho, Montana, Wyoming, and British Columbia were administered from Oregon City. The building, seen in this 1886 photograph, was the fifth Clackamas courthouse. A seventh courthouse has been proposed.

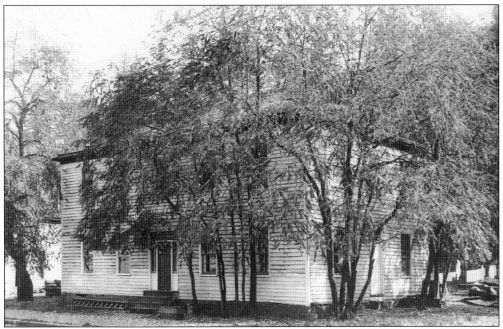

Upon his retirement from the Hudson's Bay Company in 1845, Dr. McLoughlin built this fine mansion on Main Street. It was the largest house in Oregon at that time. Although Congress took his land claim from him, he was a respected citizen of Oregon, became a United States citizen in 1851, and was elected mayor. He lived in Oregon City for 11 years until his death in 1857.

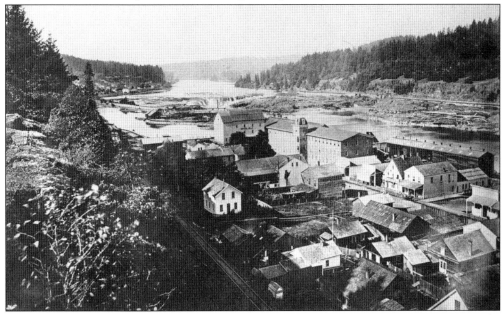

After Dr. McLoughlin's death, his house went to his daughter and son-in-law. Shortly after the death of Mrs. McLoughlin in 1860, the house was sold and converted into a boardinghouse for workers at the nearby mills. Known as the Phoenix Hotel, it had an addition to the back that allowed for about two dozen more rooms. Most of its tenants were Chinese. In this photograph, it is mostly hidden by large trees across the street from the woolen mill tower.

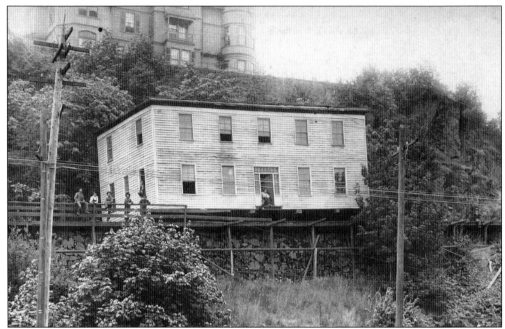

In June 1909, the McLoughlin House was moved 14 blocks from its river-level location to a park on the bluff overlooking town, a site donated by McLoughlin in 1851. The power for the move was a single-horse winching system using a capstan. The move was not without turmoil and delay as a winch shattered and the new neighbors tried to stop the move.

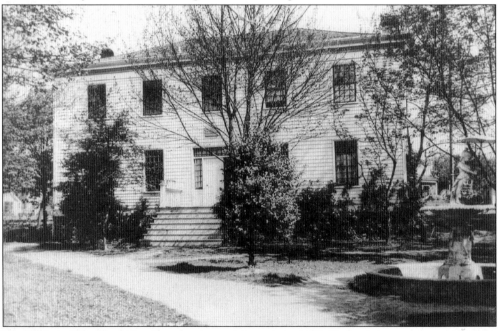

The McLoughlin House has been open to visitors since 1910. Today it is a museum owned by the National Park Service as part of Fort Vancouver National Historic Site. The McLoughlin Memorial Association, which saved the house from destruction in 1909, operates a gift shop and provides educational services for the thousands of school children that visit each year.

Starting in the 1830s, people came overland to Oregon on what was called the Oregon Trail. Before 1846, they rafted from The Dalles to Fort Vancouver. In 1846, the trail was extended over Mount Hood on the Barlow Road and ended at Oregon City. In about 25 years, half a million emigrants had arrived in Oregon City to resupply and file land claims.

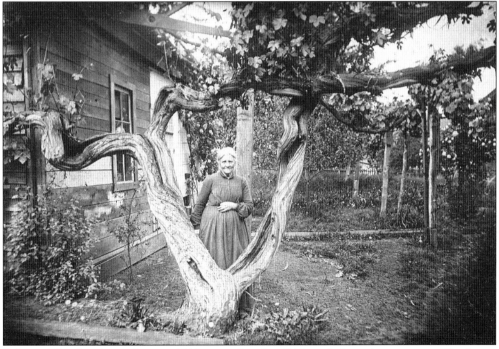

Rebecca Blanchard, seen here in 1916, arrived in the 1840s and planted a grapevine. The house was built in 1852 in the Canemah District of Oregon City and replaced an earlier cabin. Thousands of emigrants stayed in Oregon City. Most moved on to their claims in the Willamette Valley.

Used to make linen and rope, flax grows well in the Willamette Valley. Before hard currency came to Oregon, wheat was the principle medium of exchange. Sections of Oregon City and the Willamette Valley that now grow houses were once vast fields of grain. Today most wheat grows in irrigated Eastern Oregon, and grass seed for lawns and golf courses is the main crop of the valley.

When emigrants came over the Oregon Trail to the Willamette Valley, Oregon was officially "dry." Both the Methodist Mission and Dr. McLoughlin discouraged brewing or distilling. With the coming of U.S. Army troops to Fort Vancouver in 1849, the brewing of beer followed. The area just south of Oregon City is still a major growing area for hops, a vital ingredient in the making of beer.

Thousands of people left financial ruin and poor health in the East to come to Oregon, where they could claim up to one square mile of free land as early as 1843. Large farms developed in the Willamette Valley with stands of timber, acres of gardens, and flocks of cattle and sheep. Local sheep ran woolen mills throughout the valley until after World War II.

Dr. McLoughlin had the first apple brought to Oregon in 1824, and the tree is still bearing fruit at Fort Vancouver. In 1847, Henderson Luelling brought 700 fruit trees over the Oregon Trail. Joined by his brother Seth, the nursery industry began near Oregon City. Apples, pears, cherries, and peaches brought a fortune to their growers when sold in California to gold miners.

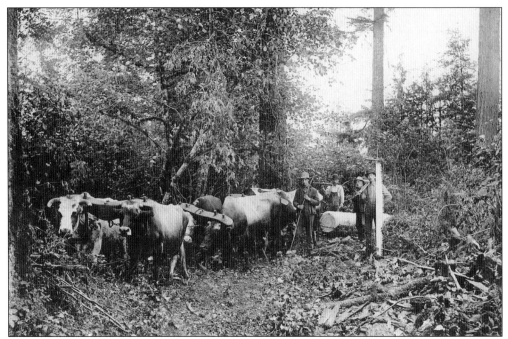

The same oxen that pulled covered wagons over the Oregon Trail were later used to clear the land of some of the largest trees on earth. Then they pulled the plows that tilled the land. Douglas fir, a softwood tree that grows to great heights, led to the lumber industry that supplied building material for houses, factories, stores, and ships.

When Oregon Trai emigrants reached old age, pioneer organizations were created to honor them. When the migration reached its centennial, Americans recalled the era through attempts to mark the old trail. Today visitors come to museums and interpretive centers to relive the past. The End of the Oregon Trail Interpretive Center is the largest private tourist destination along the Oregon Trail.

# *Two*

# Business and Industry at the Falls

Back when Oregon City was the only American settlement west of the Rockies, the people coming into town arrived by sailing ship or covered wagon. If anything was needed at all to start a new life in Oregon, or to keep it going, it was found in Oregon City.

When Dr. McLoughlin built his home in 1846, the view from his porch was of 40 structures. Toward the falls, he could see five mills—his lumber and flour mills and the three lumber and flour mills of the Methodist Oregon Milling Company. At the edge of the falls were three large warehouses, with one belonging to the Hudson's Bay Company, one to Capt. John Couch and Francis Pettygrove called the Red Store, and one belonging to the Holman brothers. Across Main Street were five stores that included the law office of Asa Lovejoy, which had in the back the printing press used by the *Oregon Spectator* newspaper in the back, the Hudson's Bay Company, a general store, the red brick store of George Abernethy called the Brick Store, and a drugstore. On the same side of Main Street as his home, McLoughlin could see two stores, the City Hotel, the Main Street House, and two churches. In addition, there were numerous private dwellings.

By 1850, there were two flouring mills and five sawmills; three large hotels, the best being the Main Street House operated by Sidney Moss; three dozen stores, including two jewelry and watch shops; 8 to 10 clothing stores; an apothecary (with a druggist, boots and shoes, confections, hardware, crockery, and liquor); two bakeries; two barbershops; a tailor (who also was a saddler and the most extensive tinware manufacturer in the territory); two cabinet shops; various blacksmiths; a plow manufactory (with a foundry, brick kiln, and oven); a Daguerrean artist; a dentist; six physicians; and a score or more lawyers. Oregon City had four churches (Methodist, Catholic, Congregational, and Baptist), a courthouse under construction, a female seminary, and a Baptist college.

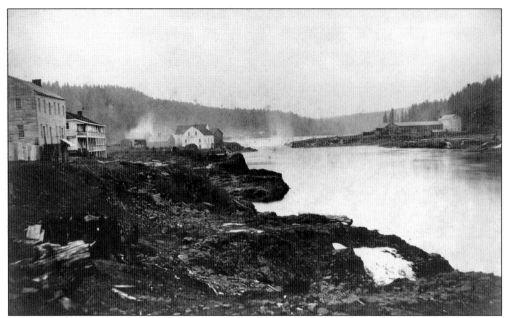

Emigrants wintered over in hotels built for them. Sidney Moss, a skilled stonecutter, was the son of a Kentucky Baptist minister. He ran the finest hotel in Oregon City, so his advertisements claimed, with the first livery stable in Oregon. He wrote *Prairie Flower*, the first novel written in Oregon, and for one year paid for the education of all the children in Oregon City.

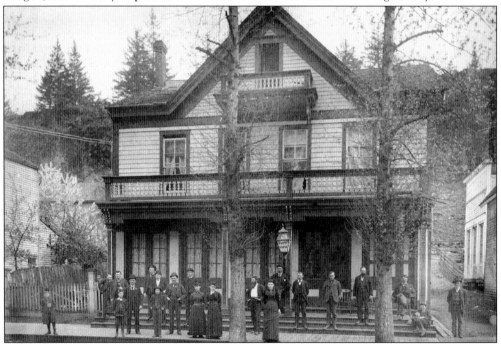

Other hotels included the Barlow House, operated by the son of the builder of the Barlow Road; the City Hotel; the Oregon House; the Phoenix Hotel, formerly the residence of Dr. McLoughlin; and the Cliff House (shown here). As Oregon City grew into a mill town, many of the hotels became boarding houses for mill workers, mostly German or Chinese immigrants.

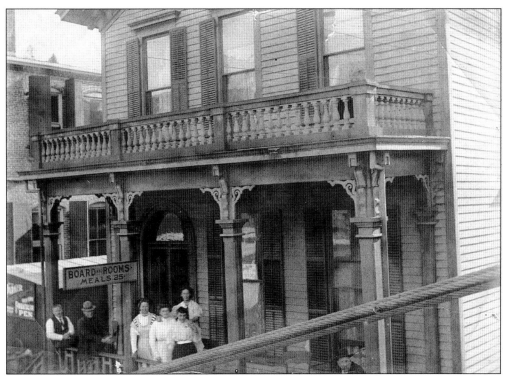

The former Thomas Charman house was moved in 1897 from the corner of Seventh and Main Streets to Seventh and Water Streets to make way for the Andresen Building. It became the Bridge Hotel. Other houses were similarly moved to make way for expansion of the business district. The home of Dr. Forbes Barclay, across Seventh Street, was moved from Main Street to Water Street to make way for the Masonic Hall.

The last of the great 19th-century hotels in Oregon City was the Electric Hotel in the Charman Building. Its name came from Oregon City's distinction as an electricity producer for itself and Portland. It was also the last to be demolished in the face of industrial expansion when it saw the wrecking ball in 1980.

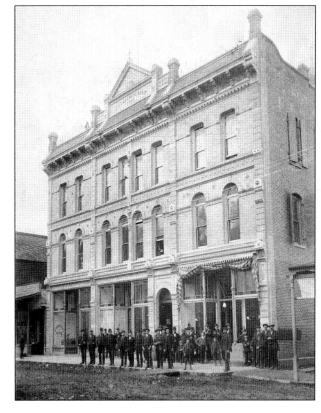

When horsepower actually meant horses, livery stables such as Cooke's were service stations of the mid-19th century. Visitors to town could garage their wagons and teams as well as have them fed and repaired. Blacksmith shops almost always accompanied these facilities. In Oregon City, there was an average of one livery stable per block on the river level.

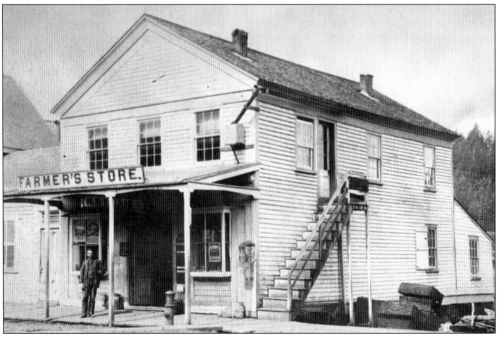

Robert Caufield immigrated to the United States, going from New York to New Orleans to Cincinnati. In 1847, he crossed the plains with his wife, Jane, two children, and Jane's widowed mother. They came over the Barlow Road, his oxen giving out before they reached the settlement. He had brought with him a stock of merchandise and soon set up a store known as the Farmer's Store.

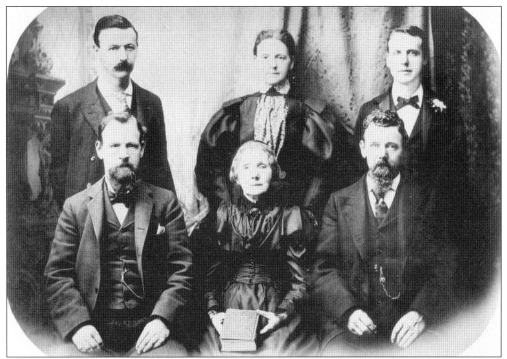

Born in Ireland, Robert Caufield (left front) and Jane Burnside Caufield (center front) settled in Oregon City in 1847 with their son David (right front). Robert became a storekeeper and county judge. Born in Oregon, Charles (left rear) became a druggist and banker, Clara (center rear) married entrepreneur Edward Eastham, and Edwin (right rear) became a lawyer and banker.

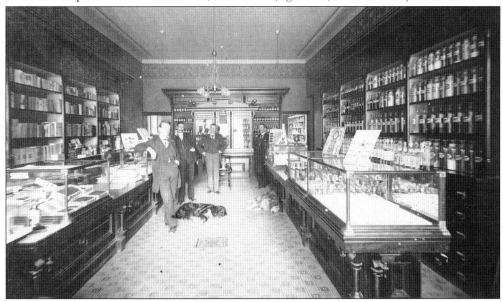

When Robert Caufield became a judge, his wife, Jane, ran the store. The youngest son, Charles, had his apothecary in a corner of the store and older brother Edwin's law office was the apartment over the store. After Robert and Jane retired to their farm, which is now the Clackamas Community College grounds, Charles took over the store and expanded it to half a block long.

Charles Pope and his sons Charles and William started the Pope and Company hardware store in the 1860s. A new brick building opened in 1873 with an opera house on the second floor. They sold stoves, tinware, plows, barrows, iron, steel, oil, pipe, and fittings. The opera house did not survive into the 20th century. The building was removed in 1980.

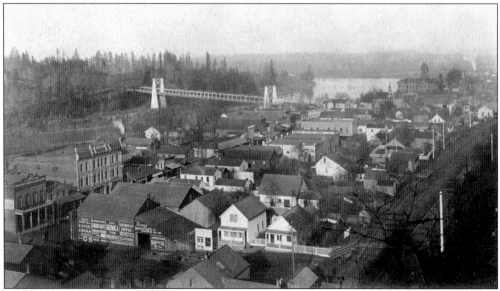

Thomas Charman was born in England and came to the United States in 1848 at the age of 19. He came across the Oregon Trail from Indiana in 1852. Here Charman purchased the former Hudson's Bay Company mercantile and operated it as a mercantile and drugstore. Charman built the expansive Charman Block Building (shown next to Pope and Company, bottom left) in the late 1880s.

Thomas Charman was a major in the Oregon State Militia, an organizer of the Oregon Republican Party, and served as mayor of Oregon City. He was an investor in several industries, founder of the OC Woolen Mills, president of the Bank of Oregon City, and an investor in the Willamette Falls Electric Company. His sons Elmer and Fred became respected businessmen in Oregon City.

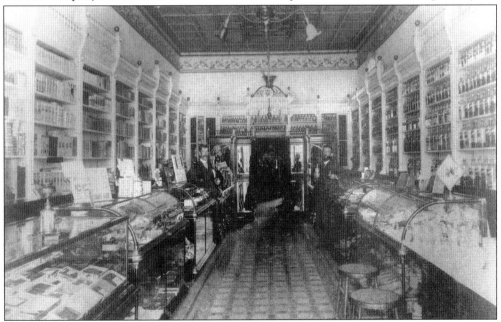

Thomas Charman was three times elected mayor of Oregon City in the 1870s and 1880s. His family, including children Fred, Elmer, and Mary, all had fine homes on Main Street near where the courthouse is today. Tom's house later became the Bridge Hotel apartments. The Charman Building, including the Electric Hotel, was a dominant feature of the river district for almost a century.

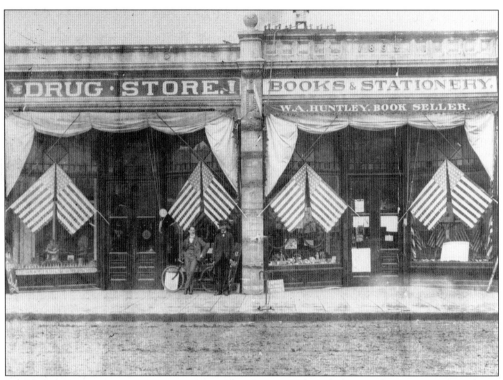

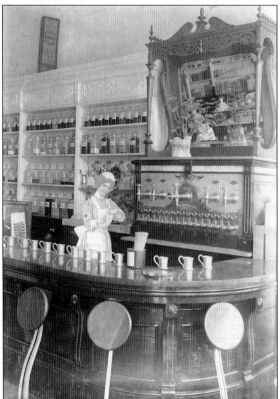

The Clyde Huntley Drug and Book Store specialized in "reliable goods" that sold on the "money back if you want it" plan. They sold the first bicycles in Oregon City, offered Kodak cameras and Butterick dress patterns, and took mail orders. According to their advertising, the ice cream sodas they made were better than one could get "in Detroit, Cincinnati, Portland or Buffalo." They became Huntley-Draper when realtor Harry Draper bought into the business.

Linn Jones was a turn-of-the-century druggist, mayor, and state senator working at various locations along Main Street when he moved to the Barclay Building. Jones lived in a large house that still stands at Sixth and High Streets. He was mayor of Oregon City when the first public elevator was built near his home.

Andrina Kate Barclay was the youngest child of Dr. Forbes Barclay, the former Arctic rescuer and Hudson's Bay Company physician at Fort Vancouver. He moved to Oregon City in 1849 where he was physician, coroner, school superintendent, and mayor. He died aiding the citizens of Clackamas County in the diphtheria epidemic of 1873. Katie was known for her business savvy and quite often bested the male competition.

The Barclay Building was built for Katie, who lived next door. It still stands next to the Seventh Street approach to the Arch Bridge. The Barclay House next door was moved around 1907 for construction of the third Masonic Hall. After Katie's death in 1934, the house was moved up the bluff next to the McLoughlin House.

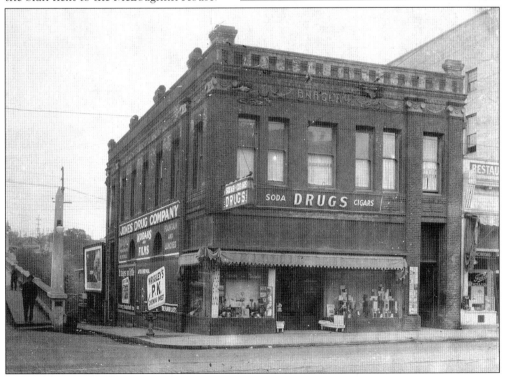

In 1849, a group of Oregon City investors began a minting company that made coins from California gold. Beaver coins were minted in this building in 1849 in $5 and $10 denominations. When Oregon became a territory in 1849, the government ordered all Beaver coins to be melted down and only a few rare ones remain today. The Oregon City Mint washed away in the flood of 1890.

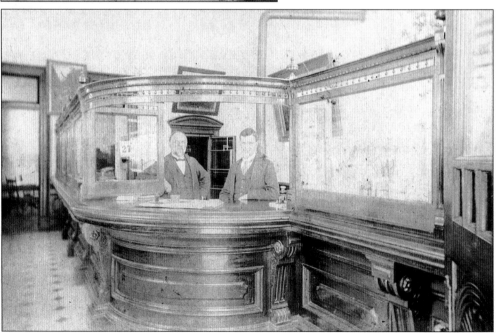

DeWitt Clinton Latourette (left) and his cousin Charles David Latourette were lawyers and bankers in Oregon City, descendants of pioneer stock. Their one-story Romanesque Revival–style Commercial Bank remained in the Latourette family until it was demolished. Its hand-hewn stones presently grace a portion of the McLoughlin Promenade. A rounded stone pilaster on the northwest corner is all that remains of the old 1866 building.

The new Bank of Oregon City, established in 1881, operated out of the Enterprise Building. It occupied the street-level floor, below the city newspaper. Bank president Charles Caufield is pictured with his dog Jack, and his brother-in-law Ed Eastham, an entrepreneur who started Willamette Falls Electric Company, is in the window above.

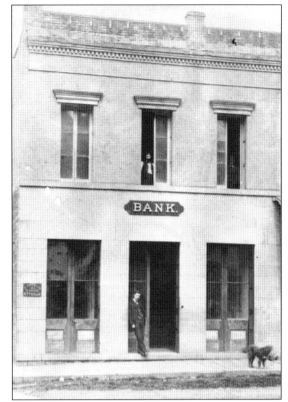

In the mid-1880s, the Bank Of Oregon City ordered a new vault for their firm. The unique round shape and the claim that it could hold $1 million made the bank appear safe. The old round vault is on display today in the entry of Key Bank up on the hilltop level.

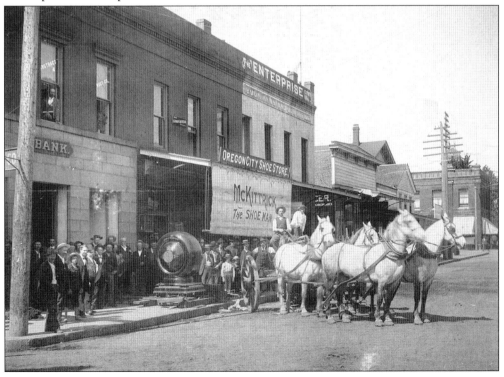

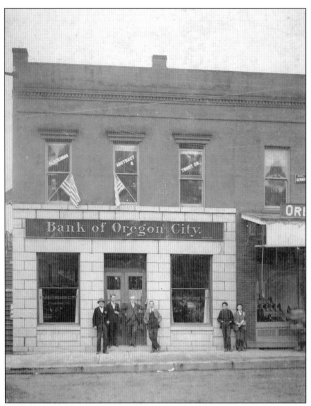

In 1892, the Bank of Oregon City merged with the older Commercial Bank located across Main Street. This business venture also represented the merger of two powerful Oregon City pioneer business families, the Caufields and the Latourettes. It reorganized under the name First National Bank of Oregon City.

The bank was established with $50,000 in capital stock by some of the same citizens who financed the early factories. Charles Caufield (right) was president. His bank had the reputation of being "safe and conservative." Edwin Caufield (center) was a vice president along with Ed Eastham. Note the round safe in the corner.

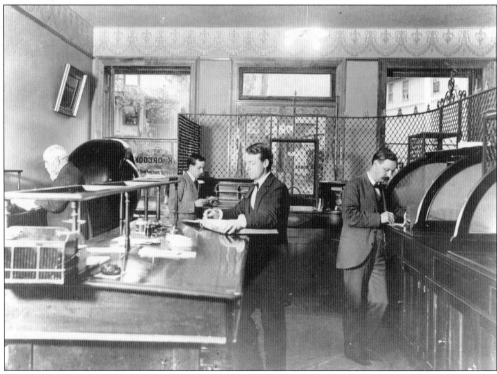

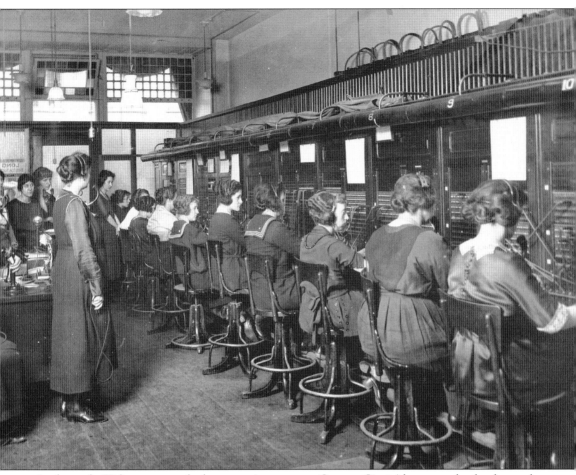

In the early 20th century, telephone service came to Oregon City. Always on the forefront of technology, the regional Pacific Northwest Bell long-distance telephone operator assistance office was in Oregon City, serving the northern Willamette Valley. Young ladies manned a row of stations asking for the name or number of whom a person wished to call.

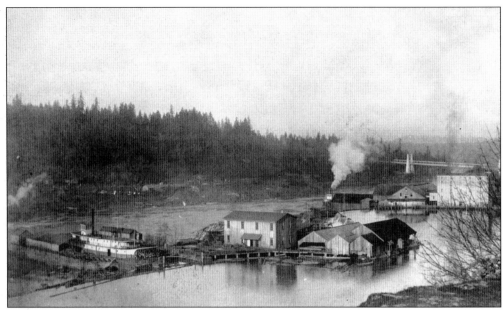

In 1832, Dr. McLoughlin ordered a sawmill and gristmill to be built using waterpower from the falls directed through a millrace he blasted out of the basalt of an island in the falls. In 1841, a group of Methodists established the Oregon Milling Company on an island in the falls, adjoining McLoughlin's claim. This is an 1890s photograph of the island mills.

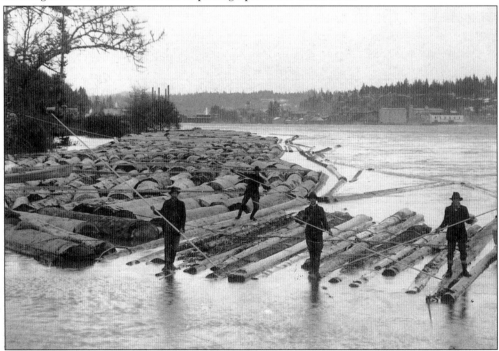

With the ready availability of both rivers and large trees, it was most convenient to float the lumber to the mills. Hundreds of trees would be tied together into rafts. This practice continued long after paper mills replaced sawmills in Oregon City. This photograph was taken in 1909 in the upper river above the falls.

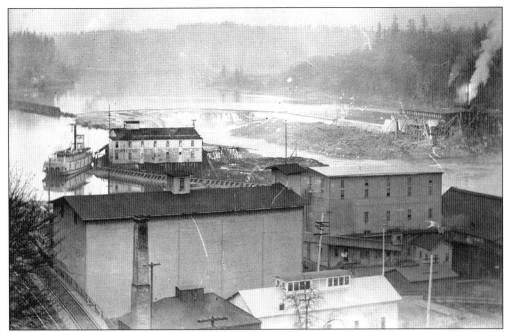

The first two mills in Oregon City were Dr. McLoughlin's sawmill and gristmill. A gristmill grinds grain, mostly wheat in the Willamette Valley, into a course meal for feeding stock or baking. A more sophisticated process grinds grain into the finer ground flour used primarily for baking. The technology of the 1830s allowed for gristmills, but by the 1860s Oregon City had two flouring mills.

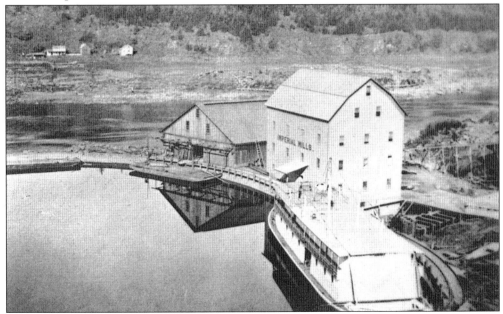

McLoughlin's plan for Oregon City did not include a First or Second Street on the river level. That was an industrial area, not platted, called the Mill Reserve. A. J. Apperson's Imperial Flour Mill and the Jacob Brothers' Oregon City Woolen Mill dominated McLoughlin's Mill Reserve. Apperson sold the flour mill, and it was enlarged and renamed the Portland Flouring Mill.

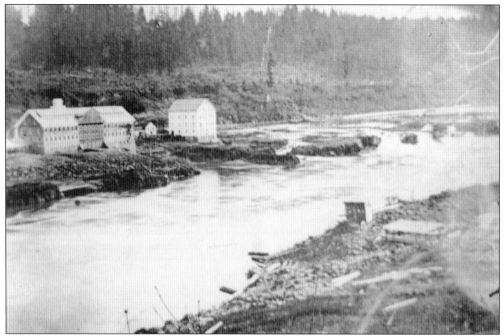

A small group of Oregon City investors during the Civil War hoped to cash in on the growing demand for Oregon woolen textiles. The investors reasoned that if remote valley mills could profit with little power, Oregon City could make huge profits when it tapped its superior source of power and nearby port. The Oregon City Woolen Manufacturing Company was the third corporation in Oregon.

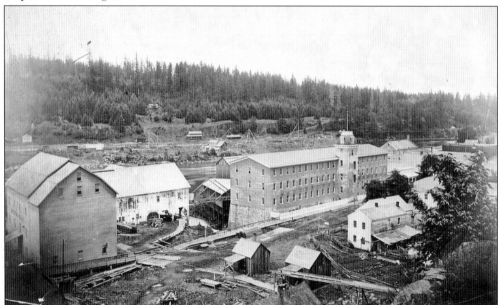

Present at an organizational meeting held a week after incorporation were two recent German immigrants, 21-year-old Isaac Jacob and his 19-year-old brother Ralph. Their expertise in the woolen business, which they learned in Germany, coupled with their drive and energy, would soon take them from being minor investors to ownership of the entire mill complex.

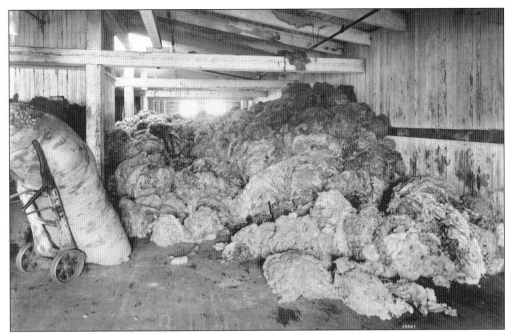

The carefully planned mill had a circular process of production and shipping. Raw materials could be imported from either up or downriver and the finished product exported down the Willamette to the Pacific Ocean and the world. Steamboats laden with fleece from the Willamette Valley would unload in the boat basin and roll their bales down to the sorting room on a system of conveyors.

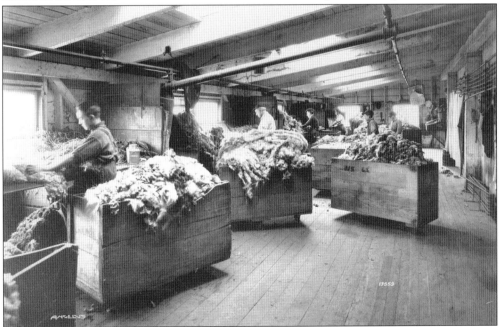

In the sorting room, the wool in the "grease" was sorted by type and quality. The strong, long-fibered Western wool was sorted by hand and graded. Only men with the most experience were allowed to be graders. Oregon City Woolen Mill's reputation for quality virgin wool products began here.

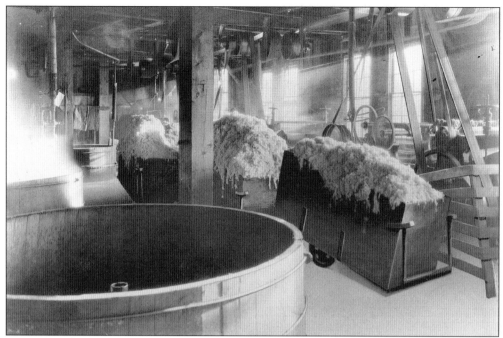

In the Dye House, the wool was bleached, by removing the grease (yolk or lanolin), and dyed. The dirty, greasy wool was scoured to a snow-white color using only pure, soft mountain water rather than injurious chemicals. Then they were dipped in the finest dyes available. Chemists used a seven-step process to insure uniform results.

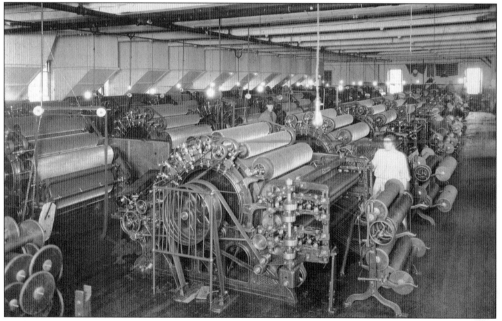

In the old main building, the wool was carded into strands and spun into thread. Replacing the traditional spinning wheels were carding machines that thoroughly separated and uniformly intermixed the wool fiber into loose cord called "roving." The cord was then wound on large spools to be spun into yarn.

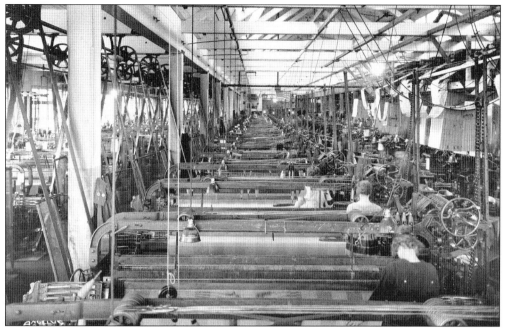

An 1890 addition doubled the size of the original woolen mills building. Here the thread was woven into cloth on gigantic looms and cut into pieces following patterns. Row after row of busy looms wove an endless variety of beautiful woolen patterns. Fine fabrics for men's clothing and women's coats were created. There were also soft, fluffy blankets of flannel and many other varieties incorporating exclusive weaves and patterns.

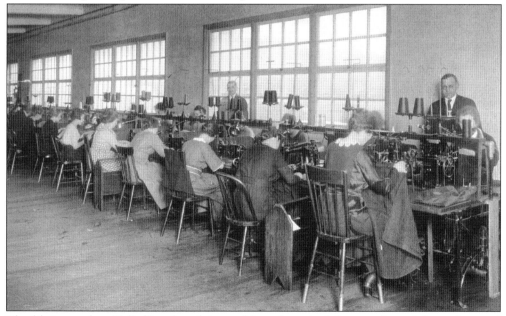

The fabric was then "fulled" or shrunk in machines that raised the nap, sheared the surface, and gave the correct texture. In the garment factory, rows of sewing machines, all operated by women, turned the fabric into coats, shirts, robes, blankets, and other woolen products. Tailoring shops in Oregon City and Portland then put on the finishing touch.

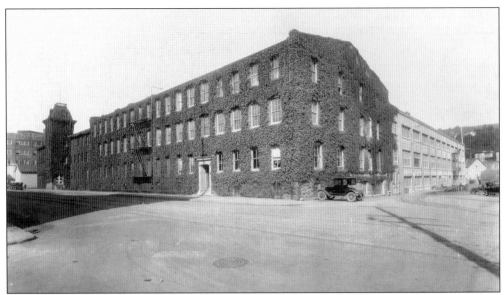

Top designers from the world of fashion were hired to design clothing. Four million pounds of Oregon wool a year was consumed. The Oregon City Woolens label was on blankets used on Arctic and Antarctic expeditions, at leading hotels, and aboard luxury ocean liners. One example is a 1931 contract for the new liners *President Hoover* and *President Coolidge* for 2,000 blankets and 1,000 steam robes.

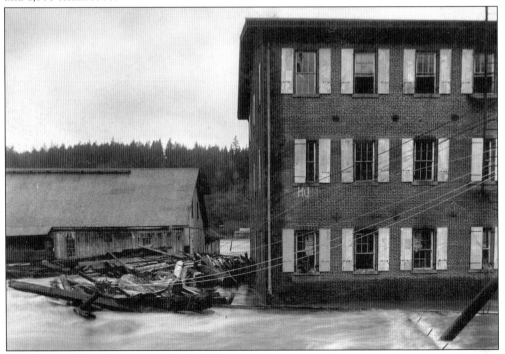

The Willamette River floods about twice every 10 years with devastating floods every 20 years. The most damage came with the flood of 1890. A fire in 1872 completely destroyed the original mill, which was immediately rebuilt. The mill went out of business in 1954 and was sold to the paper mill, along with its water rights. The old buildings were torn down in 1980.

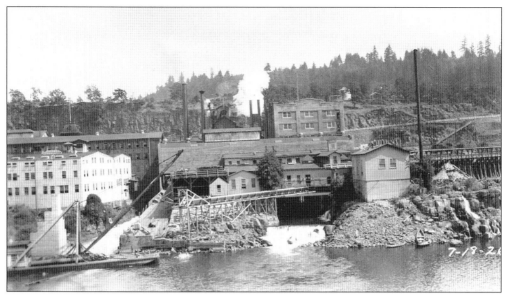

In 1908, Willard Hawley started buying up old downtown Oregon City to build his Hawley Pulp and Paper Mill that he would construct from scratch. The new mill employed 40 men and produced 20 tons of paper a day at a speed of 65 feet of paper per minute. When Hawley retired in 1917, 535 employees produced 200 tons of paper a day.

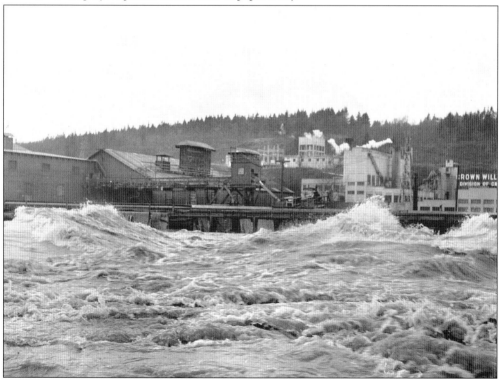

Willard Hawley Jr. and Willard Hawley III ran the Hawley Pulp and Paper Mill with decreasing efficiency until 1948. It survived at least three devastating floods and a couple of fires, but World War II proved to be the final test of effective management with aging equipment.

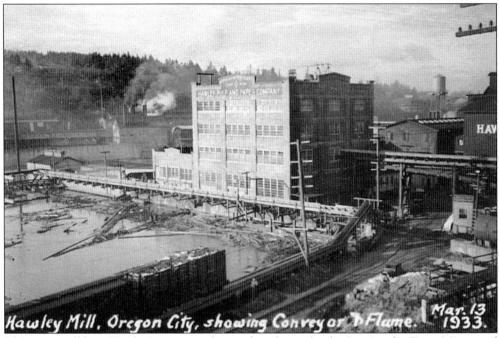

Hawley Mill, Oregon City, showing Conveyor & Flume. Mar. 13 1933.

The paper mill bore Hawley's name until it was bought out by the *Los Angeles Times Mirror* and became Publishers Paper Company. In 1950, the mill became the first to use sawmill chips rather than logs. The complex became the Smurfit Paper Newsprint Division in 1986. It was a major user of recycled newsprint. Today it is the Blue Heron Paper Company.

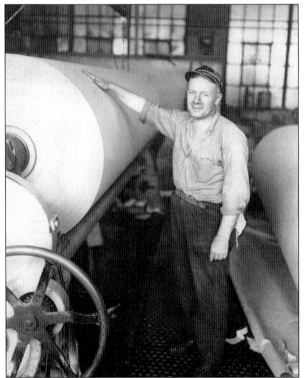

Paul Sturgis, born in 1900, worked for the Hawley and Publishers Paper Mill for over 50 years. He died in 1978. He represents many mill workers that gave Oregon City its character in the 1960s and beyond. In 1998, the paper mills on both sides of Willamette Falls became employee-owned enterprises.

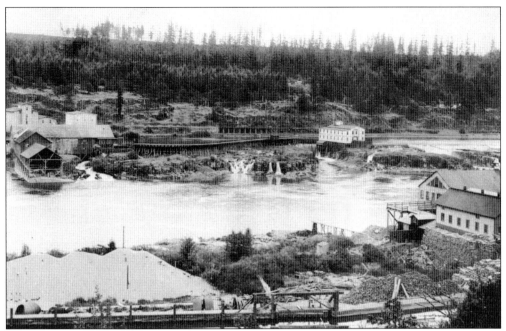

In 1880, while attending an international conference researching transporting electricity from Niagara Falls to New York City, Ed Eastham of Oregon City became determined that he could send electricity from Willamette Falls to Portland. Eastham was a lawyer and bank president, but most importantly he was an entrepreneur. By 1887, he had the water rights to the falls and most of the adjacent land.

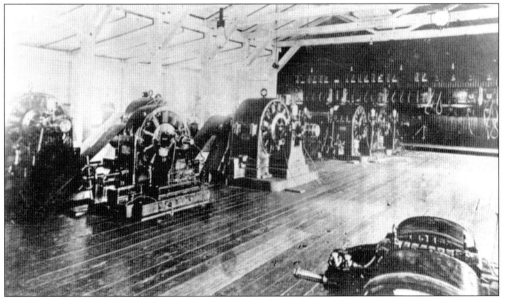

Eastham established the Willamette Falls Electric Company. Station A was a two-story building that sat on an island in the falls with 35-inch waterwheels in place. The first of six electricity-generating dynamos was connected to these wheels by belts. The lines were strung, and on June 3, 1889, the breakers were opened. Portland was lit, and for the first time in history electricity was sent more than five miles.

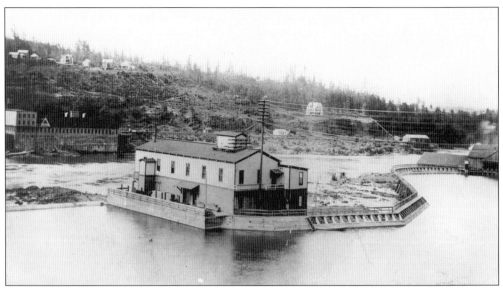

Station A was destroyed in the winter flood of 1890 and was immediately rebuilt. A single set of lines for each circuit for the new alternating current replaced the six sets of lines required for direct current. Willamette Falls Electric created the first long-distance transmission of both AC and DC.

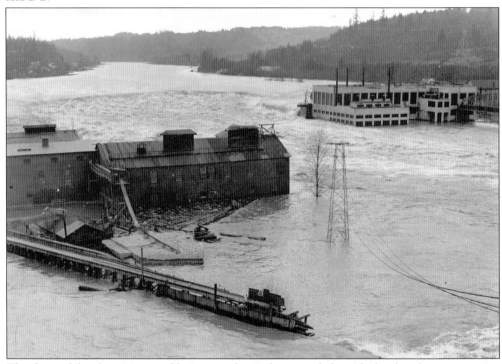

The demand for electricity steadily increased as industry and electrified railroad transportation grew around Willamette Falls, and in 1897, Station B was built and Willamette Falls Electric Company became Portland General Electric Company. Edward Eastham, the father of Oregon City electricity production, rode his fame and fortune to the Oregon state legislature, where in 1902 he died on the capitol floor. He literally worked himself to death.

# *Three*

# WILLAMETTE RIVER NAVIGATION

The Willamette River provided an avenue of transportation for American Indian canoes. It brought many settlers and merchants on sailing ships to Oregon City. The newest innovation was the use of steam to power paddle-wheel riverboats.

The steam engine was an English invention that powered the 18th century Industrial Revolution. Using a steam engine to power a riverboat was an American invention of the early 19th century, starting with Robert Fulton's *Clermont* on the Hudson River in 1807, but it was the British that first brought the steamboat to Oregon.

The first boat to ply the Willamette River under steam power was the Hudson's Bay Company's *Beaver* in 1836. Built as a wind-powered sailing ship, the *Beaver* had been converted to steam earlier that year. It sailed to Oregon with its steam engines not in use and then converted to steam power at Fort Vancouver. It ran aground in Vancouver, British Columbia, in the 1890s. The first riverboat built in Oregon was the sail-powered *Star of Oregon*, which was launched in 1842 by its builders Joseph Gale and Felix Hathaway. Its shipyard was on Swan Island, below the future location of Portland.

The first steamboat actually built in Oregon was the *Columbia*, constructed in Astoria early in 1850. Less than a year later, on Christmas Day in 1850, Lot Whitcomb of Milwaukie launched the 160-foot *Lot Whitcomb*. It was the first steamboat built on the Willamette, constructed in Milwaukie by Berryman Jennings, S. S. White, and Jacob Kamm. These two little side-wheelers were the first of scores of boats built in the decade of the 1850s. They worked the Oregon City to Astoria route, off-loading cargo onto sailing ships that were too large to maneuver the Columbia. Several local boats departed Oregon City daily, and at least once a week a steamship departed Oregon City for San Francisco. It was very expensive to operate the *Lot Whitcomb*, so whenever possible they would supplement their income by towing sailing ships on the Columbia River upstream from Astoria.

Orphaned at 13, John Comminger Ainsworth moved to Iowa and worked on Mississippi riverboats, advancing to the rank of captain. At age 26, he was in California looking for gold. In 1851, he was in Milwaukie as captain of the *Lot Whitcomb*. He lived briefly in Oregon City in a fine mansion south of town. After the *Lot Whitcomb* was sold, he ran a mercantile in Oregon City.

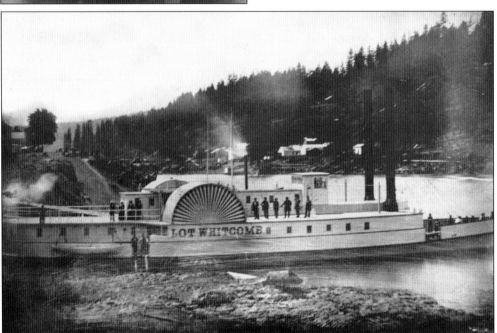

On Christmas Day in 1850, Lot Whitcomb of Milwaukie launched the 160-foot *Lot Whitcomb*. It was the first steamboat built on the Willamette, constructed in Milwaukie by Berryman Jennings, S. S. White, and Jacob Kamm. It ran the Oregon City to Astoria route, off-loading cargo onto lsailing ships too large to maneuver the Columbia. The *Lot Whitcomb* was sold to a California group in 1854.

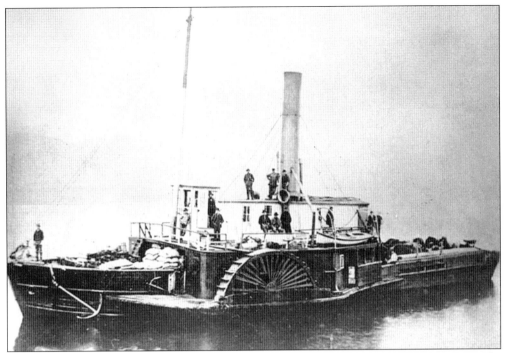

The *Beaver* was the first steam-powered vessel to ply the Willamette and Columbia Rivers. The Hudson's Bay Company sailed the vessel to Fort Vancouver in 1836 with the steam engine and paddle wheels disconnected and then had it converted. Long after the Hudson's Bay Company left Oregon, the *Beaver* continued to ply the Pacific Ocean out of Victoria. It ran aground in the 1890s in Vancouver, British Columbia.

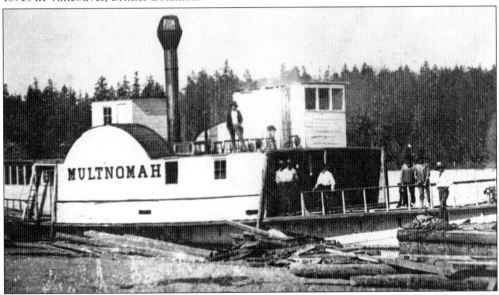

Side-wheelers such as the *Lot Whitcomb* and *Multnomah* were impractical in Oregon. By the late 1850s, steamboat lines were using the more popular stern-wheelers on the rivers. Stern-wheelers were practical because their paddle wheels were less prone to be buried in mud once the boat was nosed up to the shore and loaded. The first stern-wheeler on the Willamette was the *Jennie Clark*.

In 1862, Portlander Stephen Coffin started a steamboat line on the Willamette. Coffin purchased the *James Clinton*, *Relief*, and *Enterprise* and dubbed them the People's Transportation Company. A rate war emerged and in a compromise, the Willamette went to the People's Transportation. They began expanding and enlarged the boat basin on the Oregon City side of the falls, cutting into McLoughlin's Mill Reserve.

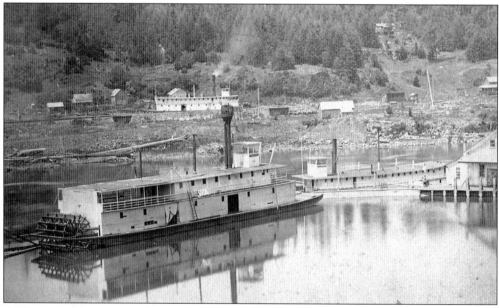

An open rate war emerged between Ainsworth's Oregon Steam Navigation Company and Coffin's People's Transportation Company. In 1863 and 1864, both companies lost heavily as passengers could sail from Portland to Salem for 50¢, including a bed and meal and freight, which previously cost $100 a ton to transport. In an 1865 compromise, the Willamette River went to the People's Transportation.

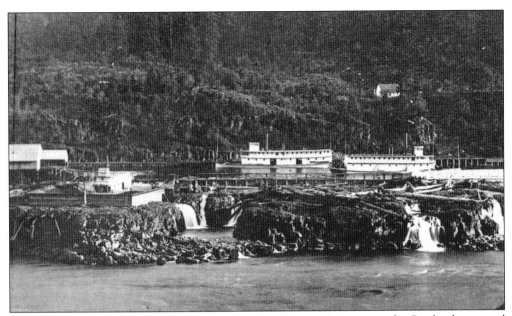

Oregon City became the transportation hub of the Willamette River, even after Portland surpassed the city in size and importance. All river traffic had to be detoured around the falls. After the Willamette Locks were built in 1873, Oregon City maintained prominence by providing steamboat services such as a dry dock on an island in the falls.

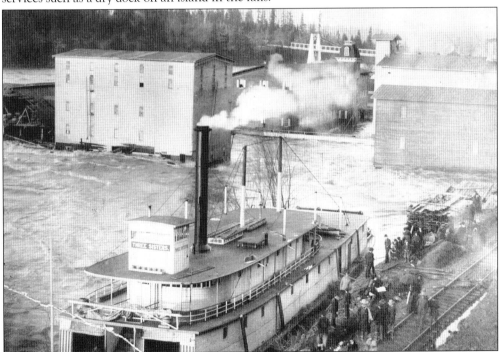

About once or twice every 10 years, a devastating flood hit the Willamette River. Cities at water level up and down the river suffered damage. Oregon City had more to lose with each flood as its life revolved around the river and the falls. After a flood, the debris would be removed as fast as possible and repairs were made to buildings so business could go on.

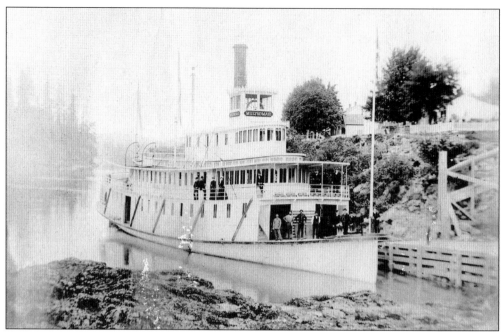

As old, unreliable side-wheelers needed to be replaced, larger, more elegant stern-wheelers emerged. Beautifully appointed with cabins as luxurious as fancy lodgings, steamboats became floating hotel rooms. The travel may not be as fast as the new railroads, but the travel was in style. By the 1880s, the race for fancier boats reached its peak, and new boats started to become smaller again.

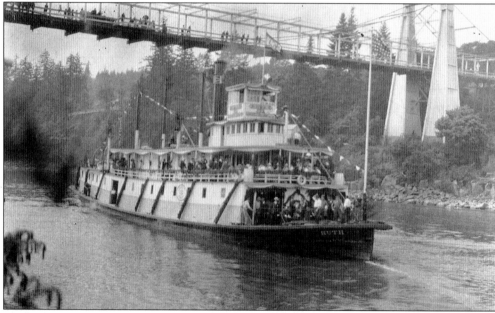

Jacob Kamm was a Swiss immigrant who learned steamboating on the Mississippi. Lot Whitcomb induced him to come to Oregon in 1849, and Kamm helped build the *Lot Whitcomb*. As Whitcomb's chief engineer, he also built the *Jennie Clark*, Oregon's first stern-wheeler, and several others. He became a partner of Captain Ainsworth as well as his chief engineer while in Oregon City. He amassed a fortune with the new Oregon Steam Navigation Company.

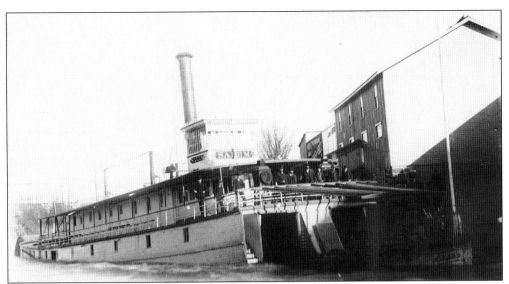

With over 70 years of docking, loading, unloading, repairing, and building steamboats, accidents were bound to happen. Boats caught fire, blew up, hit snags, ran into docks, ran aground, or just sank at their moorings. Several boats attempted, intentionally or not, to float over the falls. At least one such event involved a captain that had been drinking. One boat was successful, running the falls during a flood.

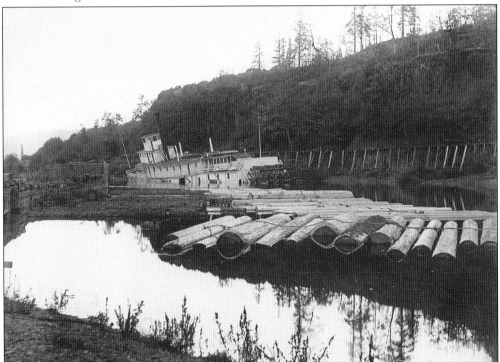

The *William Hoag,* seen here in the locks, sank near Oregon City. The *Gazelle*, on April 8, 1854, docked at Canemah. Intending a brief stay, Capt. Robert Hereford ordered engineer Moses Tonie to tie down the safety relief valve and keep up a full head of steam. Witnesses saw the engineer race off the ship and out of sight just before the boilers blew, killing 20 people on board.

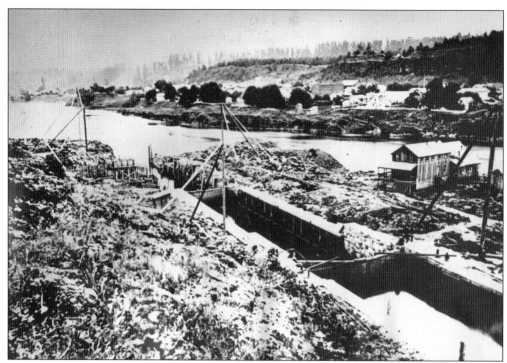

Willamette Falls is a scenic wonder, a magnificent fishery, and source of power for the entire region, but it is also a barrier to transportation. It would require a set of locks to transport an entire ship around the falls. The state of Oregon raised $200,000 to pay for the locks project. Lock chambers were made from stones quarried at Carver by Horace Baker.

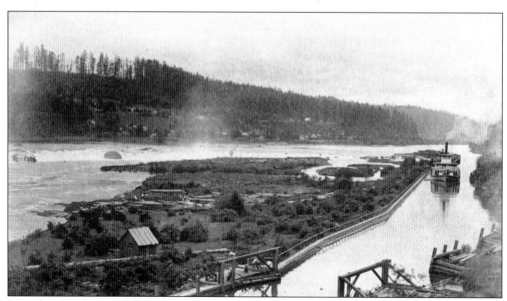

The state bonds required the project to be open to the public no later than New Year's Day of 1873. On New Year's Eve, the project was nearly completed and capable of lifting a steamboat up the river. A boat was found and brought to the locks. The *Maria Wilkins* negotiated the locks, up and down, and the system was officially opened January 1, 1873.

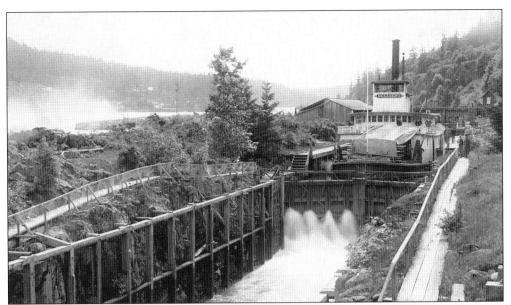

The locks were operated over the years by a number of owners until the U.S. Army Corps of Engineers purchased them in 1915 for $375,000. The corps began a series of renovations that lasted from 1916 to 1921. The lock chambers were deepened from three feet to six feet as the need for deeper draft vessels increased.

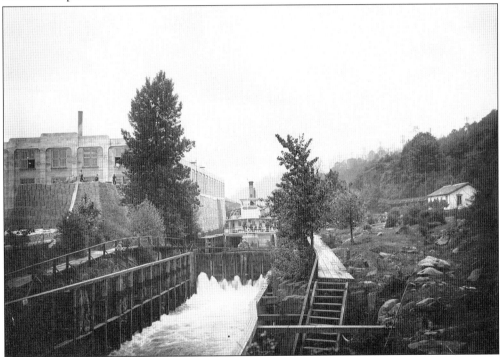

In 1941, the original wooden-lock gate doors were replaced with metal gates. Until then, the gates were opened and closed manually. The antiquated capstan winches were replaced with the hydraulic system used today. The locks are the oldest multiple lift system in the United States and therefore the oldest still in use. Older locks had only a single lift at a time.

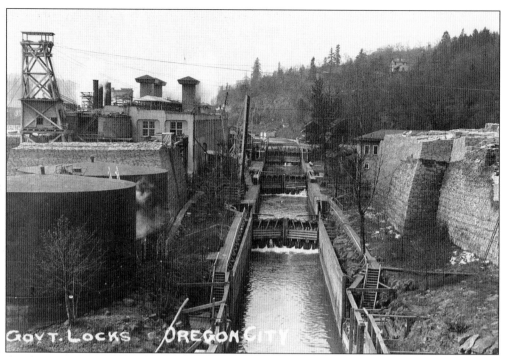

GOVT. LOCKS - OREGON CITY

Average passing time is 45 minutes going upstream and 30 minutes going downstream. The unique design of the locks uses gravity to flow 850,000 gallons of river water into or out of each chamber. Vessels are lifted or lowered 41 feet. Boats are limited to a draft of 6 feet, 37 feet wide, and 175 feet long, allowing space for opening gates.

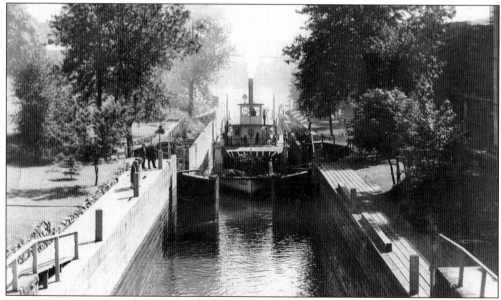

The Willamette Falls Locks and Canal are public property, accessible from the parking lot behind West Linn City Hall. It has picnic tables and a large anchor dredged from the river. In the spring, when the air is clean and the flowering cherries are in bloom, it is a perfect place to escape for an afternoon or extended lunch period.

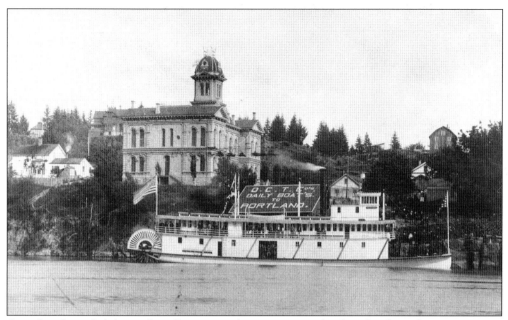

As railroads eroded the profits of large steamboat companies hauling freight and passengers over long distances, a new business called the Oregon City Transportation Company started, offering low-cost river transportation between Portland and Oregon City. There was a definite "ona" pattern in naming their boats—*Altona, Latona, Leona, Grammona, Oregona,* and *Pomona.*

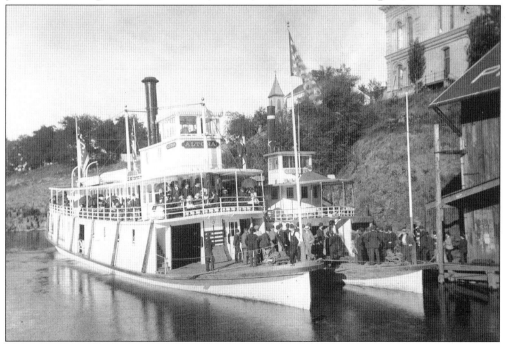

The Oregon City Transportation Company was called the "Yellow Star Line" due to the yellow star on their smokestacks. They promised daily boats to Portland and freight rates cheaper than the railroads. The line lasted from the 1880s through the 1920s, until the Depression and even cheaper balloon-tired truck transportation put them out of business.

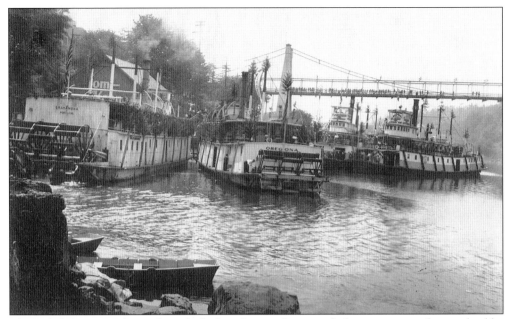

The Eighth Street Dock was the only dock in Oregon City strictly for passenger and general public use. Docks near the falls served the mills and as ferry landings for West Linn. Today the City of Oregon City operates a general transportation dock further down river. Old Eighth Street Dock still sits quietly out of sight under a highway viaduct behind the courthouse.

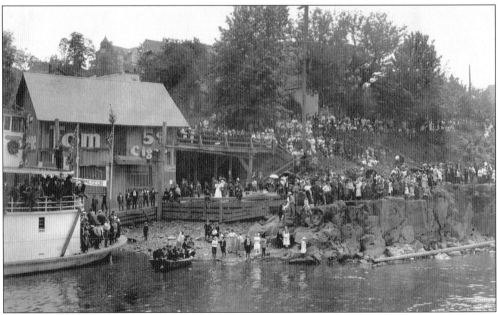

The era of steamboats in Oregon City lasted from 1851 until 1954. The last Oregon City steamboat was the *Claire*. The Eighth Street Dock saw numerous celebrations, especially when the annual Fourth of July parade extended to the river. It even saw steamboat races that started at the Clackamas River and ended at the bridge.

# *Four*

# RAILROADS, TROLLEYS, AND STREETCARS

People arriving by water, in canoes or ships, founded Oregon City, but wheeled vehicles had a greater impact. Covered wagons brought pioneers over the Oregon Trail. Oregon City's memorial to that era is the End of the Oregon Trail Interpretive Center. The covered wagons lost their roads and trails to the faster and more nimble stagecoaches.

When steamboats plied the Willamette, it was wheels on wooden rails holding up flat cars pulled by mules that portaged people and their goods around the falls. Almost as soon as people found a way to sail boats around the falls, the boats fell into disuse by the advent of the railroad. People who used to walk to work could later ride on metal-wheeled trolleys and later interurbans.

The word "railroad" literally means a road made of rails on which trams with wheels, grooved to straddle the rails, ride as they are pushed or pulled. The first rails in Oregon were wooden, and the first horsepower was literally horsepower. The first roads of rails were at portages around the great falls or rapids that blocked Oregon's mighty rivers.

The Oregon Country's oldest railroad was the North Side Portage of the Cascades of the Columbia at what is now Stevenson, Washington. It was built in 1850 (while Washington was still part of the Oregon Territory) to accommodate Oregon Trail pioneers taking the river route from The Dalles to Fort Vancouver and on to Oregon City. In 1853, there was a portage railroad at Oregon City around Willamette Falls.

All of these used mule or horsepowered flatcars called trams. In 1862 came the first mechanical railroad engine, tiny by today's standards. It was a steam engine called the *Oregon Pony*. As small as it was, it was too heavy for wooden rails, which had to be strapped with iron belting.

Eventually, all portage railroads were put out of business by locks and canals, but there was some resistance. Willamette Falls was first to have locks in 1872–1873. Floods affect all portages and locks. Willamette Falls is inundated during the regular floods that come about every 10 years.

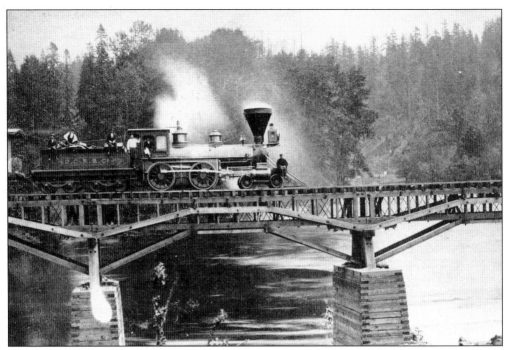

In 1869, Ben Holladay entered the long-distance railroad business. His Oregon Central "Eastside" Railroad won the concession in a contest against the Westside Railroad to see which could lay the first 20 miles of track. Holladay easily went from the ferry below Oaks Park to Sellwood through Milwaukie to Gladstone and Oregon City as far as the mouth of Beaver Creek at New Era.

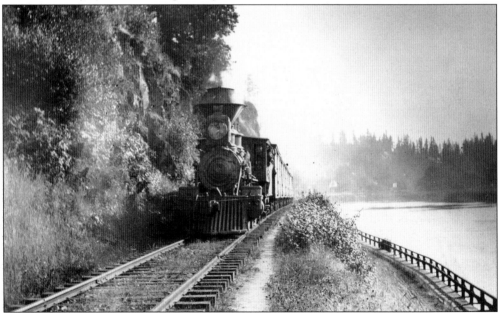

A standard method for that time was a contest to lay track. The west side route was delayed in building a trestle around Elk Rock by rocks falling from above and fires set on the trestle. The Oregon Central became the Oregon and California. Engines painted O-C were converted to O&C, and on Christmas Eve 1869, the inaugural train ran from Portland to Oregon City.

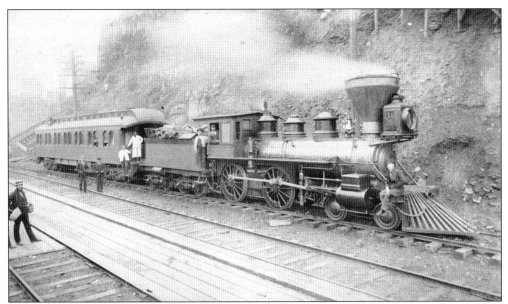

In 1870, Ben Holladay owned both the Willamette Falls Portage Railroad and the People's Transportation Company steamboat line. That same year, he began laying track for the Oregon and California Railroad south of New Era. The line was extended to Salem that year and to Roseburg by 1872 before being shut down by the Panic of 1873, an economic crisis, and Holladay's bankruptcy.

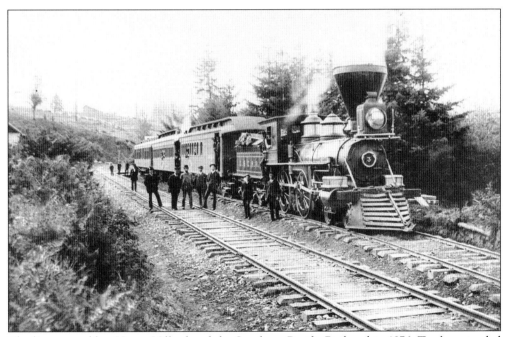

The line was sold to Henry Villard and the Southern Pacific Railroad in 1876. Tracks extended toward the California line while a road was being constructed out of Sacramento. The golden spike for this line was laid in 1887 near Ashland, and Oregon was finally connected to California by rail.

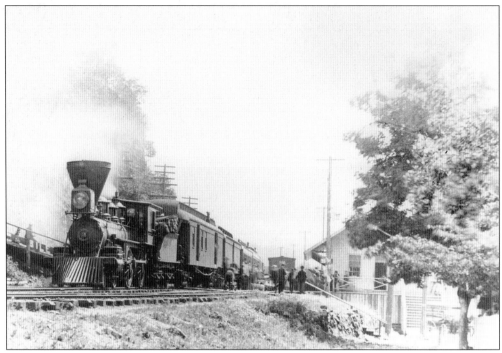

Two stations were built in Oregon City, a passenger station at the foot of Seventh Street and a freight station on Center Street near Abernethy Creek. The passenger station was the center of town from 1870 until it was torn down in 1954, when passenger service ended. Today there is an Amtrak Station north of town.

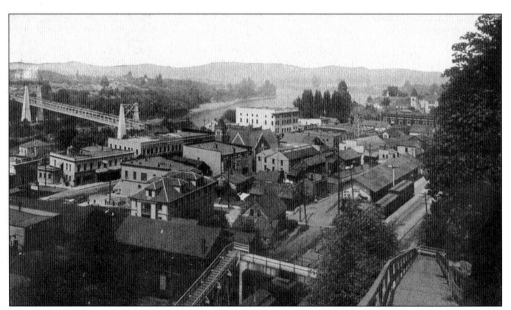

The railroad's payment for building the line was in alternate sections of land, which were to be surveyed, entered onto the state rolls, and sold off for actual money. In 1916, a lawsuit against the O&CRR for failing to enroll their lands gave the land to the State of Oregon.

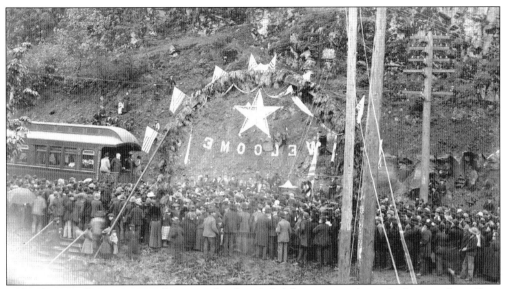

All rail traffic between Seattle or Portland and California goes through Oregon City. Over the years, this has included President Hayes in 1880, seen here thanking Oregon for its vote; Pres. Teddy Roosevelt in 1903, on his way to Salem; and the Liberty Bell, on its way from Philadelphia to the San Francisco's Panama-Pacific Exposition in 1915. The sign faces the president, not the camera.

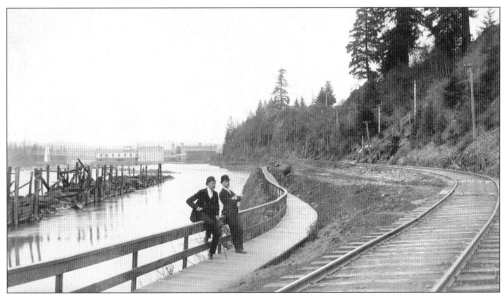

The railroad track between Oregon City and Canemah, part of the richest mile of the northwest Willamette Falls portage, is the oldest track in the state. The O&CRR extended the route for hundreds of miles, and the Willamette Falls locks made off-loading steamboats unnecessary. This spelled the beginning of the end of Oregon City's importance.

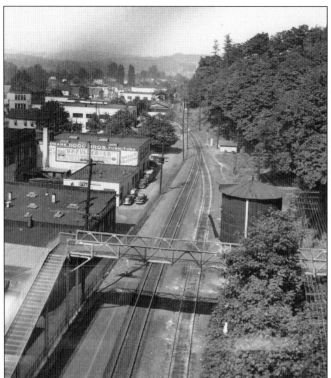

From the early 1880s to the mid-1950s, the railroad tracks, elevated along the base of the bluff, divided Oregon City's river level business district and upper level residential districts. Steps that descended the bluff also had to cross the tracks, usually on overpasses. Buildings tucked out of sight from the river now were painted with advertising that could be seen from the trains.

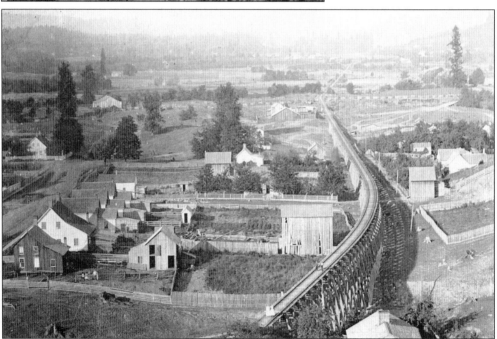

North of the main business district, the railroad tracks drop down to the level of the rivers. From Eleventh Street to Sixteenth Street there is a wooden trestle over Center Street. North of the trestle the tracks are prone to flooding in the Willamette River's decadal events. The freight station and an interurban station were located at the base of the trestle.

Railroad steam engines, as well as steamboats, require a huge amount of fuel to operate. The fast-growing softwood trees of western Oregon were sacrificed to run the engines of commerce and the papermaking industry. Barges and train cars of wood were pulled up next to steamboats at dock or trains in station.

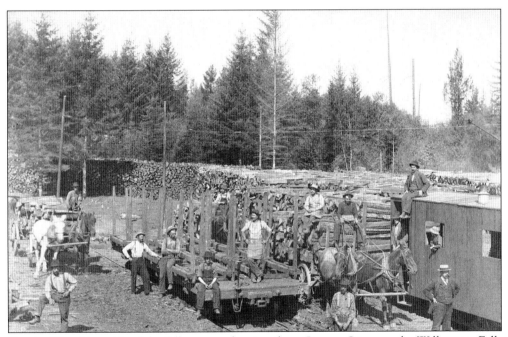

On the West Linn side of the falls, across the river from Oregon City, was the Willamette Falls railroad that ran from the Tualatin River to Oswego. One of its principal contracts was to supply wood. Trees were felled and sectioned into cordwood before being taken to the trains and boats. Ironically, the Willamette Falls line was an electric railroad.

In the wet climate of western Oregon, structures made out of wood decay fast. Old buildings that are not kept up and regularly painted will collapse from age. Periodically, sections of Oregon City were rebuilt. Urban renewal came to the Oregon City train station in 1929.

Railroad Avenue was widened in the 1929 renewal of the Oregon City train station. Adjacent buildings lost additions that had been built out over the street. The station lost a ramp that took goods straight to track level. Twenty-five years later, the station was removed and replaced with on-street parking.

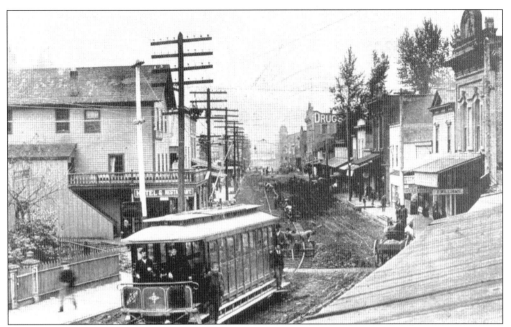

From the 1870s through 1890s, trolleys ran up and down Oregon City's Main Street. Oregon City and Portland were connected by way of a route now called Portland Street in Gladstone. The *Helen* made daily runs between the two cities. Although Portland had a cable car going up Council Crest from Goose Hollow, Oregon City did not have transit service to its upper districts.

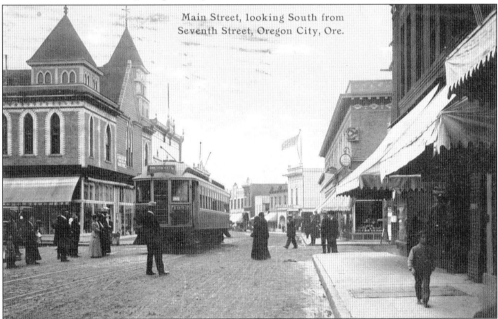

George Steel moved to Oregon from Ohio in 1862. He married into an Oregon City family by exchanging nuptials with Eva Pope in Oregon City in 1869. His father-in-law ran a hardware store and opera house in Oregon City. Steel financed the building of local interurban railways, one of which was the Portland-Oregon City interurban in 1890, the first to be electrified using electricity generated at Willamette Falls.

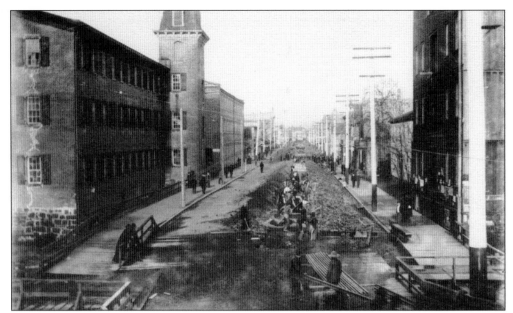

Construction began in 1872 and originally reached only the end of the business district on Main Street as far as Fourth Street at the Pope hardware store. In 1901, the line was extended to Canemah. As more trains were added to the system, the need for passing lanes became necessary. In Oregon City, such double-track sidings were found at three places.

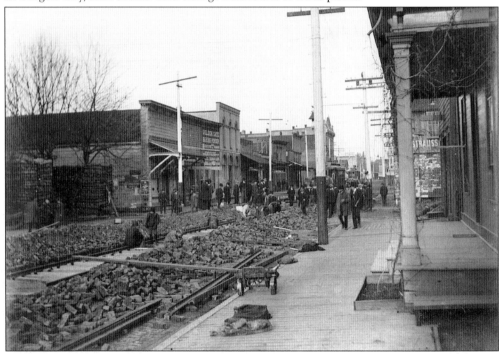

The interurban, full-sized railroad cars running on city streets similar to today's light rail, started in Portland in 1889. They used existing trolley lines as much as possible. When the line was extended to Oregon City, starting in 1890 and completed in 1893, power came from Station A in Willamette Falls. The Portland-Oregon City line became the nation's first true electric interurban.

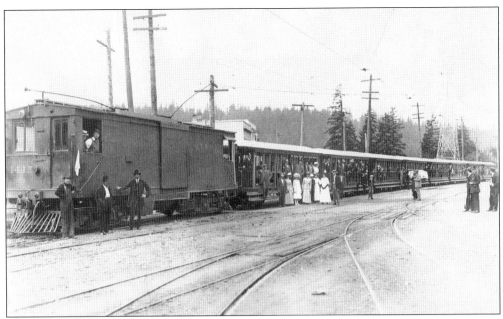

The Willamette Valley and Southern Railroad (WVSR), often called the Beavercreek-Mount Angel Railroad, connected numerous communities in the east side of the Willamette Valley from the 1920s through the 1940s. Starting at Mount Angel, its tracks once went north through Monitor, Yoder, Molalla, Liberal, Mulino, and Beavercreek and ended at its station at Fourteenth and Center Streets in Oregon City.

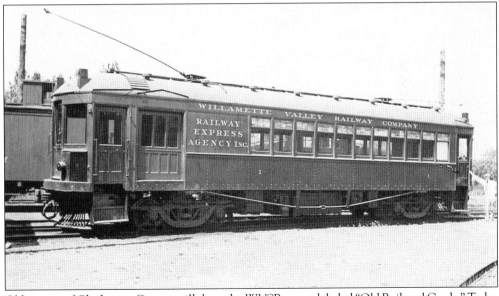

Older maps of Clackamas County still show the WVSR route, labeled "Old Railroad Grade." Today a Southern Pacific line using engines labeled "Willamette Valley Railroad" services sawmills in many of the communities served by the former interurban. In 2000, Union Pacific acquired the Southern Pacific and all of its subsidiary lines.

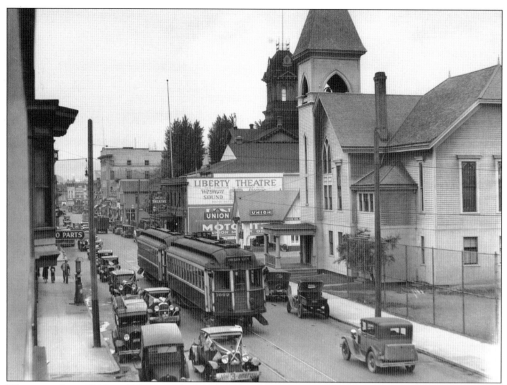

The years from 1893 to 1954 were the height of rail traffic in the Oregon City area. The interurban and streetcars made travel to Portland easy, and the Southern Pacific made interstate travel affordable. In the 1930s, interurban passengers getting off the train at the Liberty Theater or Clackamas County Courthouse might have had to dodge a parade of new automobiles.

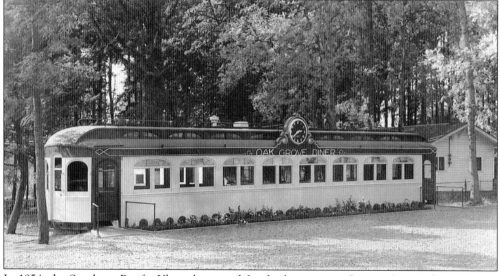

In 1954, the Southern Pacific *Klamath* stopped for the last time in Oregon City at the passenger depot next to the modern city elevator. To ride Amtrak's Coast Starlight to Los Angeles today, an Oregon City resident must first travel to Portland or Salem to "catch the train." Old trolley cars ended up in dining rooms of upscale restaurants, and old interurban cars became roadside diners.

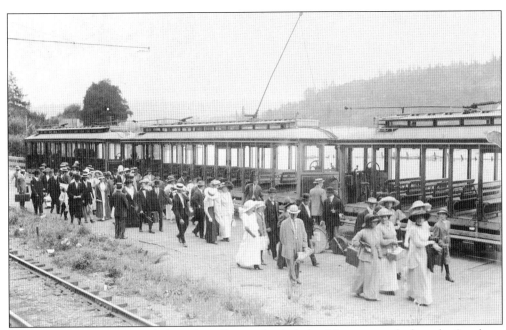

In 1900, the line was extended south to Canemah. A slight delay occurred when the Southern Pacific line refused to allow the electric "juice-powered" line to cross its tracks. The interurban brought in a crew on a Sunday and installed crossing frogs. The railroad owners could not get a court injunction to stop the work because the sheriff could not be located on Sunday morning.

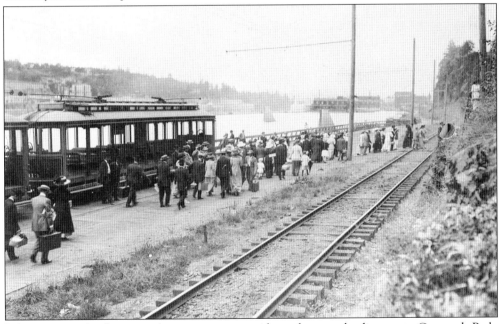

It became popular for interurban passengers to ride to the steps leading up to Canemah Park. The steps zigzagged up the bluff to Oregon's first amusement park, complete with one of Mr. Ferris's wheels, a covered dance floor, and a ballpark. By 1905, Canemah Park had competition in Portland with Oaks Park. The interurbans sponsored special Sunday outings to various parks and Chautauquas.

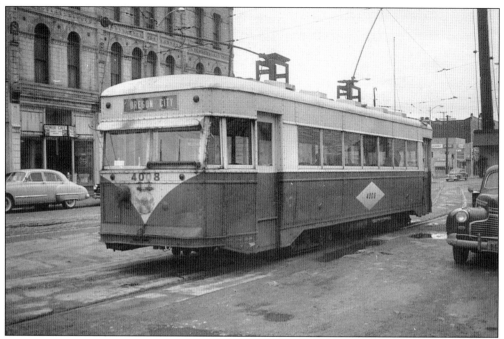

After World War II, due to safety and liability issues caused by large-sized railroad cars competing with automobiles, the interurbans were phased out for newer streetcars, which looked much like the old trolleys. Not as many people lived in the old city core and more were becoming dependent on automobiles.

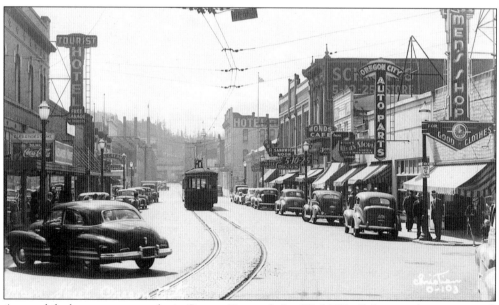

Automobiles became very popular in Oregon City, and after World War II that popularity increased. Constant vigilance was required on Oregon City's old narrow Main Street. The Portland-Oregon City interurban was discontinued in 1958 due to competition from new trackless, rubber-tired electric buses and eventually overhead wireless diesel buses.

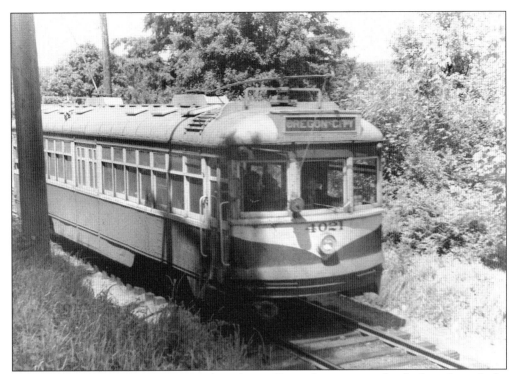

The tracks in downtown Main Street have been all paved over except for the line through the paper mill to Sixth Street. This short segment is used about twice a week for switching boxcars being sent out of the mill via the Southern Pacific tracks that come in from Canemah, usually late at night as not to disrupt automobile traffic.

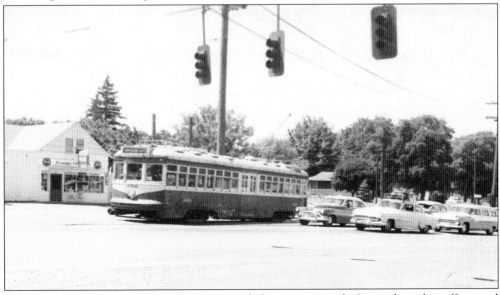

The interurban crossed U.S. Highway 99E in Gladstone at an angle. It was the only traffic signal on the new "Super Highway" and many automobiles missed it, causing much damage. Today the only vestiges of the old railroad to Oregon City are the unusually large power poles lining the old route.

The ultimate in downsizing railcars for city streets were the tiny trams of the Portland Electric Power Company, or PEPCO, which ran throughout the urbanized areas of Clackamas County and suburban Portland. One of the old PEPCO cars was used by Portland General Electric Company as an entry in local parades. Ironically, it was on rubber tires and pulled by horses.

*Five*

# LAND TRANSPORTATION HUB

Throughout the late 19th and early 20th centuries, a simple wheeled vehicle provided the most convenience with the least attention. They were the horsepowered vehicles that held from one to four people and/or baggage. Livery stables abounded as people needed to garage their oat burners. Companies were begun to transport people from where they were to where they needed to go.

Delivery carts for rent were called drays, and to this day, baggage is called drayage. Larger coaches that ran people and baggage from town to town on a regular schedule, or stage, were called stagecoaches. Large stagecoaches, or omnibuses, held up to 20 people for tours or mass transit off the iron-railed track.

As streets were paved, wheels that were protected from wear and tear by iron rings called tires were replaced with wheels ringed with a tire of hard, vulcanized rubber. To further soften the impact of hard wheels on hard ground, or to prevent narrow wheels from being mired in Oregon's ever-present mud, the companies that were making the hard rubber tires developed a new type of tire. The new balloon tire, a circular tube of soft rubber filled with air, made the ride much smoother and the road less demanding. As technology advanced and the internal-combustion engine was developed, the frames for these new horseless carriages were the simple buggies.

Arguments continue in historical journals regarding the first self-powered automobiles in Oregon. It is known that Henry Wemme imported the first such vehicle to Portland in 1899, a Stanley Steamer. Every year from then until his death in 1914, he brought a new make and model to his home in Portland. Wemme also owned the first airplane in Oregon.

Oregon City can claim the first automobile made in Oregon. It cannot claim the first ferry or bridge in Oregon but had both from an early date. Oregon City does have a street that is different from all others in the state, in fact the only one in the United States and one of only three in the world—a vertical street.

Call them estate wagons, buckboards, buggies, hacks, or drays—they were horsepowered vehicles. Hacks were early horse-drawn taxis and gave their name to the self-propelled taxis yet to come. Throughout the 19th century, Oregon City saw every type of horse-drawn vehicle in addition to the oxen or mule-drawn covered wagons that got a number of the residents here in the first place.

Buggy, buckboard, sulkey, or surrey, these two- or four-wheeled carriages transported business people to their stores or markets, families into town or back home, and young couples to social engagements. The Willamette River and the Southern Pacific Railroad connected Oregon City to the world. It was horse-drawn carts that connected the area residents to town until the dawn of the 20th century.

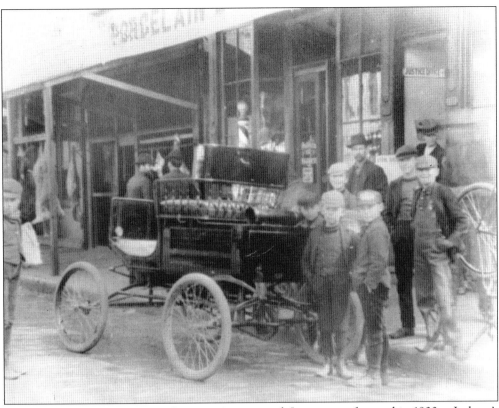

The first automobile in Oregon City was not imported. It was manufactured in 1900 at Jackson's Bicycle Shop on 714 Main Street. Made in 1901 in Portland, the vehicle that is on display at the Oregon Historical Society is Oregon's oldest existing automobile. Shipping lines to Oregon made it easy to import vehicles, and Oregon City never became an automobile-manufacturing center.

Henry Wemme, of Portland, was Oregon's best-known collector of automobiles. In 1912, he purchased the Barlow Road route of the Oregon Trail to promote his vacationing interests in the Mount Hood area. Upon his death, he willed the Barlow Road to the people of Oregon in perpetuity. Oregon City also had an auto collector with an Oregon Trail connection in Harley Stevens Jr., pictured here in his 1899 Waverly.

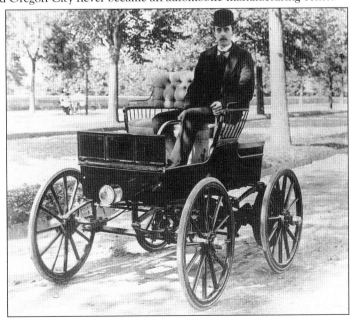

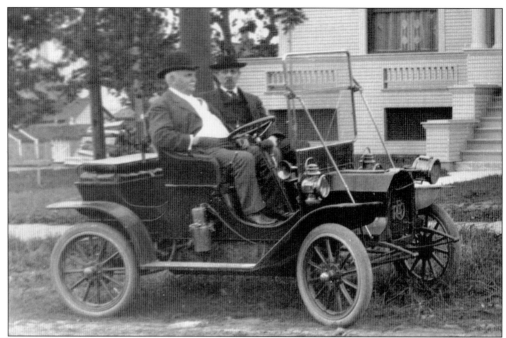

Harley Stevens Sr. was a partner to Medorem Crawford during the Civil War, and they acted as armed escorts to Oregon Trail emigrants as they crossed the plains in the era when the U.S. Army was called East. Harley Stevens Jr., the son of Harley Sr. and the grandson of Medorem Crawford, used a portion of his wealth to collect cars, including a 1908 REO.

Businessman Chambers Howell, Doctors Hugh and Guy Mount, and socialite Nan Cochran were proud of their Fords and Marmons. They showed them off whenever possible during the 1910s, even decorating them for parades. Edward Flynn loved speed, and he collected automobiles that could be raced. He also built the fastest speedboat on the Willamette River.

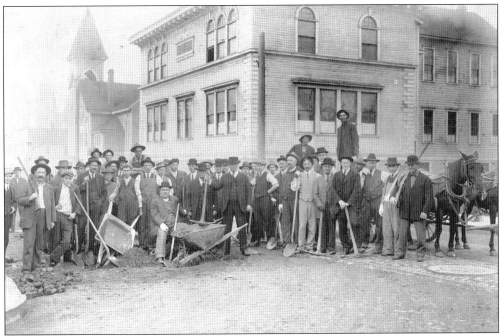

The first roads in Oregon were not surfaced with stone or asphalt. In Western Oregon, where rainfall is plentiful and dirt turns to mud, roads were surfaced with wood. City streets were graveled. The result of this 1910 Oregon City businessman's protest was the paving of Main Street with cobblestones. Sidewalks were still wood. Note the brick-lined streetcar tracks.

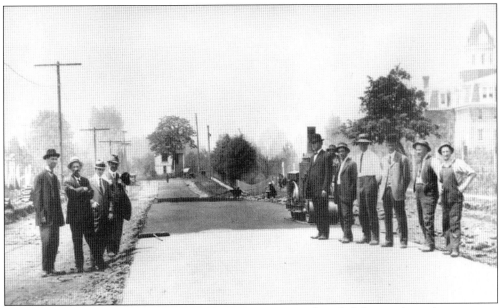

In 1849, building began on the first of the many "territorial roads." One such road connecting Oregon City to East Portland became Eighty-second Avenue. Crossing the Clackamas River from Gladstone, formerly North Oregon City, this area has been completely altered by the construction of Interstate 205. The Sister Agnes Baby Home Orphanage is now the site of the sewage works on Agnes Street.

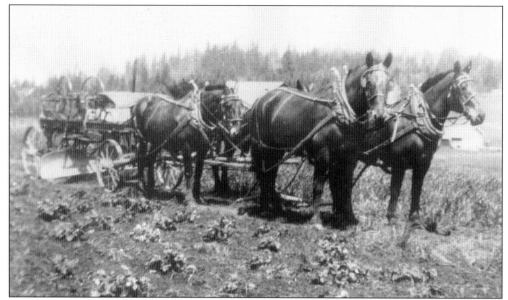

As county seat, Oregon City is home to the county transportation department, which is responsible for building and maintaining all county roads. The 1920s development of a "market road" system greatly increased the number of miles of county roads. Equipment such as horse-drawn graders and steam-powered rollers were housed in county facilities along the banks of Abernethy Creek.

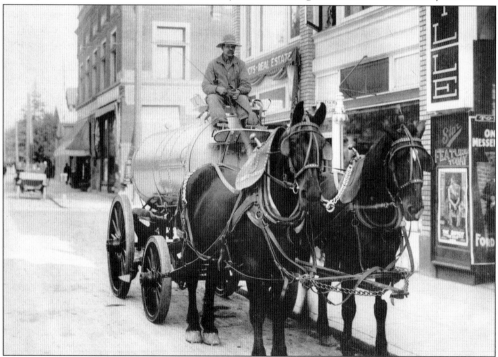

Almost two decades after the first automobile arrived in Oregon City and long after the public got accustomed to private individuals showing off their fancy cars, city public works crews still used horse-drawn equipment such as this new sprinkler used to keep the dust down during dry summer and autumn days.

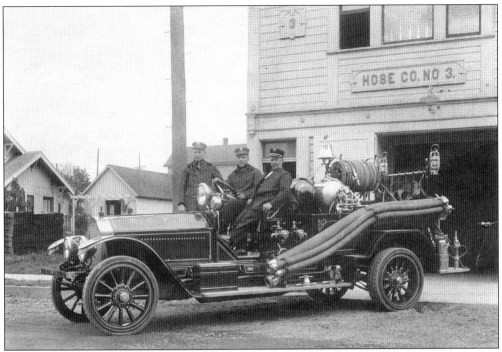

By the 1920s, the most essential public vehicles had converted to gasoline-powered engines. Oregon City had three fire departments. Cataract Hose Company, across from the woolen mills, and Fountain Hose Company, across from the courthouse, used hose carts connected to their stationary pumps. Company No. 3, located on the bluff level, used a horse-drawn steam engine before this new truck.

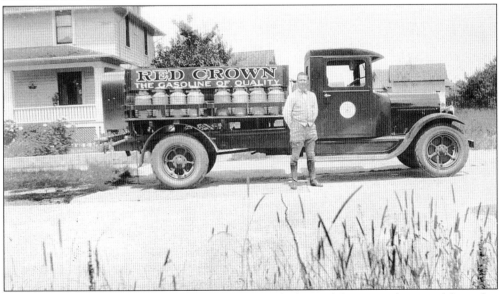

Before the coming of service stations to fully service vehicles, Red Crown gasoline was delivered to cars in five-gallon containers similar to steel milk cans. By the 1950s, Oregon City had four service stations along Highway 99E and another on the bluff level. Union 76 or Mobilgas were dispensed from pumps with domed tops. Attendants would wash the windshield and check oil levels.

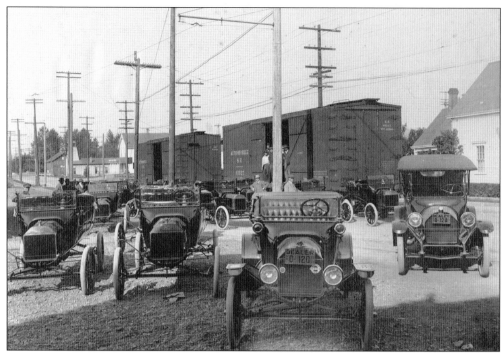

By 1904, Ford Motor Company was shipping boxcar loads of automobiles to Oregon City for sale out of their dealership next door to Jackson's Bicycle Shop. A city ordinance barred freight cars on Main Street. Whenever a shipment of Ford cars arrived by boxcar and were unloaded for the dealership, there would be crowds to watch the parade of new cars down Main Street.

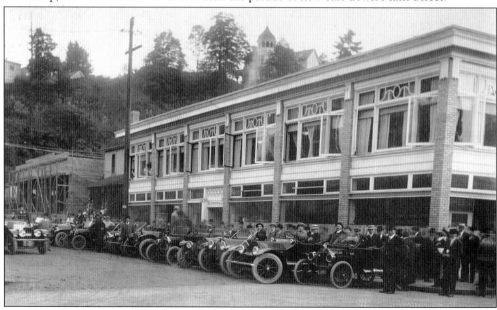

When the Commercial Club Building was constructed in 1914, its style was called "streetcar era commercial" with large, wide glass openings to view the showrooms filled with new cars. Oregon City was a Ford town, with dealerships in the Pacific Highway Garage and, by the 1940s, at Weidler Ford. A Pontiac dealership came in the 1960s.

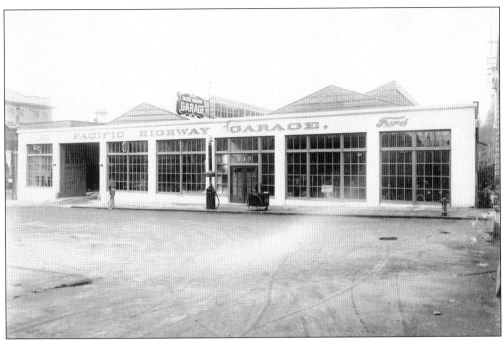

As the automobile ultimately replaced steamboats and horse-drawn carriages, the advent of garages replaced both the dry dock in the river and the livery stables downtown. The building occupying a half block along Seventh Street next to the train station was named after U.S. Highway 99E, the Pacific Highway. A portion of the building was removed to create Railroad Avenue.

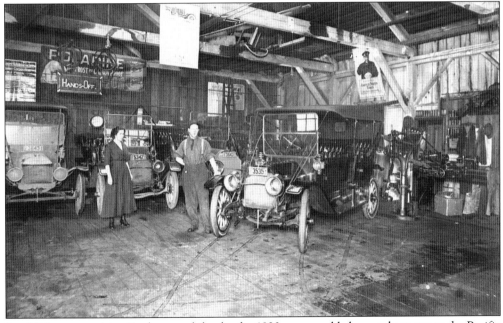

In addition to repairing Ford automobiles, by the 1920s, one could also purchase one at the Pacific Highway Garage, as well as buy gas. Complete automotive service was available with inside lifts. Storage was also available. An old Studebaker stagecoach, with a "Body by Fisher," was stored in Miller's General Motors Garage.

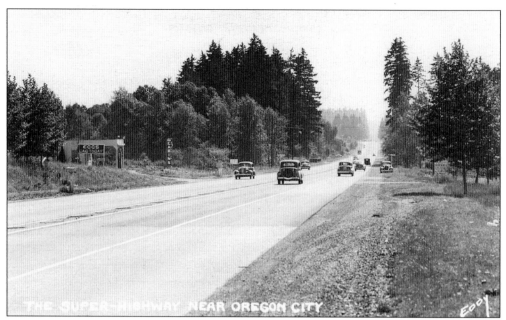

The 1844 legislature, meeting in Oregon City, recognized the need for a road from Oregon City to the Willamette Valley. They also allowed toll roads to be built at the promoter's expense, which was to be recovered in charges levied for the use of the road. The next legislature approved Sam Barlow's Mount Hood Toll Road on the Oregon Trail, commonly called the Barlow Road.

Territorial roads, post roads, market roads, and federal roads followed these earliest roads. Macadam roads came to Oregon in the 1890s. Mr. MacAdam's system consisted of contouring roads and putting a level of gravel under the surface of brick, slate, or finer gravel held in place by oil. U.S. Highway 99E, locally known as the Superhighway, was finished through Oregon City in the 1920s.

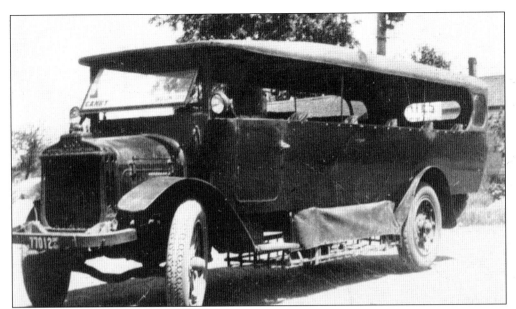

Buggies converted into horseless carriages were not the only horse-drawn vehicles to be made into gasoline-engine contraptions. Oversized stagecoaches called omnibuses became diesel-powered intercity buses. They would replace the interurbans for city-to-city mass transit, as they did not require tracks or overhead electric lines. Air pollution was still a problem of the future.

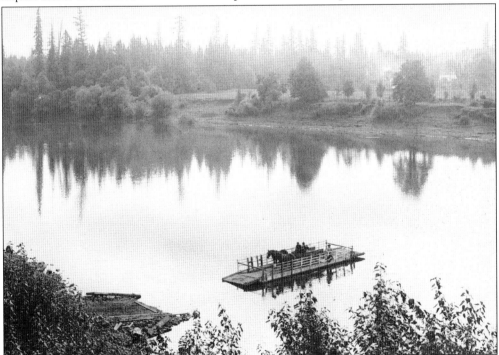

The 1844 legislature allowed ferries and toll roads to be built at the promoter's expense, which was to be recovered in charges levied for the use of the road. The territorial road connecting Portland with Salem by way of Jesse Boone's ferry is still called Boones Ferry Road today. An Interstate Highway System bridge replaced the ferry in the 1960s.

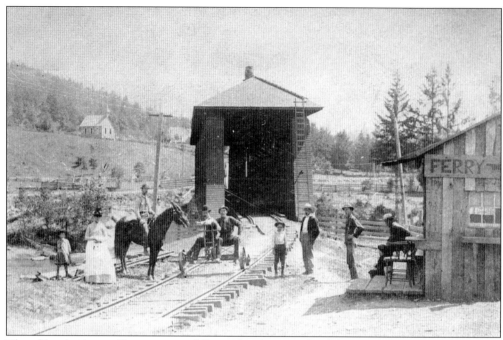

The oldest bridge in Oregon crossed Dairy Creek west of Hillsboro in 1846. In 1859, a bridge crossed the mouth of the Tualatin River across from Oregon City. In 1870, the Oregon and California Railroad built the first railroad bridge in Oregon across the mouth of the Clackamas River at Oregon City.

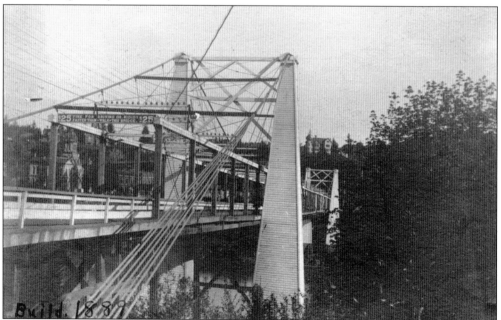

The earliest highway bridges across the Willamette at Portland, Oregon City, Salem, and Eugene came in the late 1880s, all replacing ferries. In Portland, the first was the Morrison Toll Bridge of 1887, but the Stark Street Ferry continued operation until 1895, when the bridge toll was removed. The first free bridge was in Oregon City in 1889.

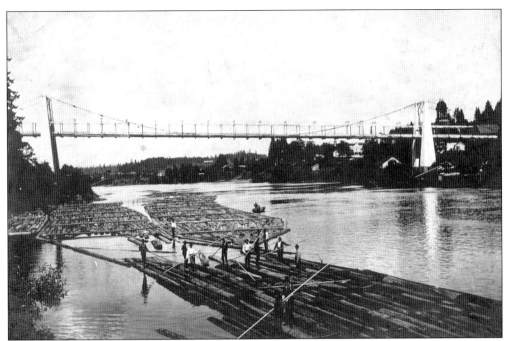

The first suspension bridge built west of the Mississippi River was erected in 1888 across the Willamette River between Oregon City and West Linn. The Pacific Bridge Company built it, and it opened to traffic in 1889. A second suspension bridge, for foot traffic only, later connected the Oregon City and West Linn paper mills during the 1920s construction of the new Arch Bridge.

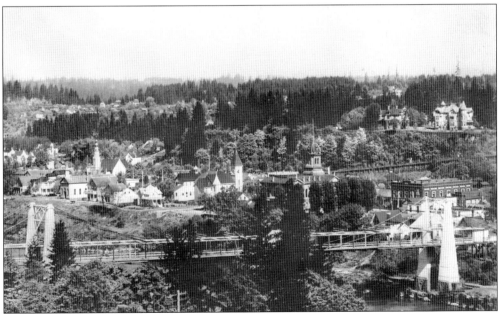

The same year the suspension bridge opened electricity was produced at Willamette Falls and transmitted to Portland. Multiple lines of wires were strung across the top of the new suspension bridge. The bridge appears in almost all photographs of Oregon City between 1889 and 1922, when it was replaced.

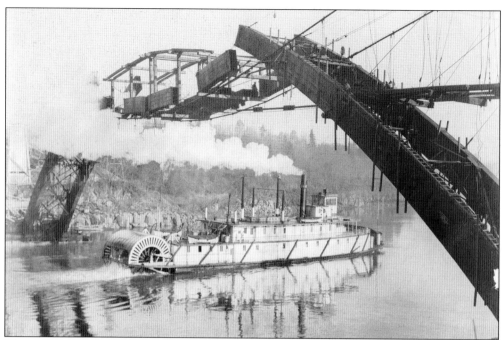

The "Most Beautiful Bridge in America" is the 1922 Oregon City-West Linn Bridge. Oregon State bridge engineer Conde McCullough built the 850-foot, concrete arch spanning 350 feet of river, his only bridge in the Portland area. The Arch Bridge was the first of 162 bridges McCullough built in Oregon. Almost all of the others were constructed along the Oregon Coast Highway, US 101.

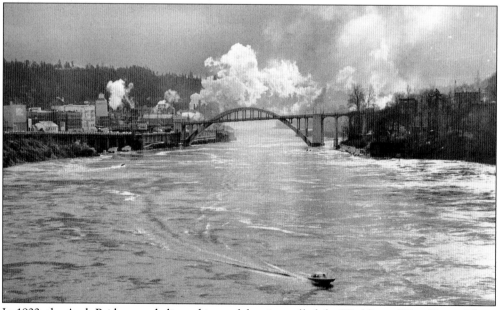

In 1922, the Arch Bridge was dedicated in a celebration called the Wedding of Two Cities. There was a bridge queen, parade, and even a wedding held at the center span. A sign on the West Linn side of the bridge states, "Entering Oregon City." One day an official-looking sign was fixed just below the first stating, "A Suburb of West Linn."

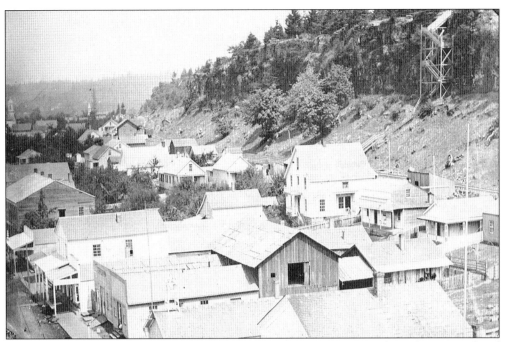

Oregon City has grown up and away from the falls. As business and industry have spread and taken more land on the river level, residences were built on the second level, now called the McLoughlin District. Getting there was a challenge. A 90-foot-high, steep bluff bounds the second level. American Indians had a narrow trail up Singer Creek.

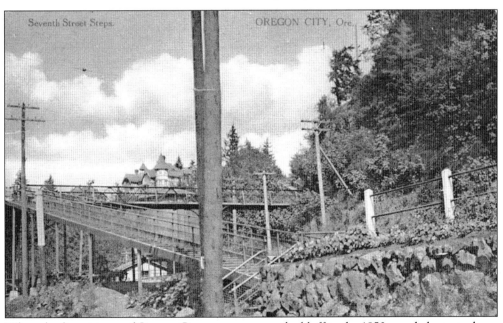

When the first citizens of Oregon City to move up on the bluff in the 1850s needed a route down to work and back up to home, they built steps. A set of wooden steps was built in 1867 from Third Street. A carpenter, G. R. H. Miller, constructed the stairs. Other steps descended from Seventh, Fifth, and Fourth Streets up on the bluff.

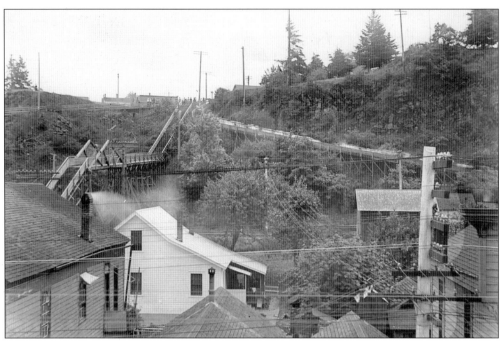

The Singer Creek Trail, seen in the top left of the photograph, was widened by projecting it out on wooden supports, hanging over the edge of the cliff. In 1909, the McLoughlin House was pulled up Singer Creek Road by a single horse turning a capstan. Sandbags were placed on the cliff side to keep it from taking out the trestle.

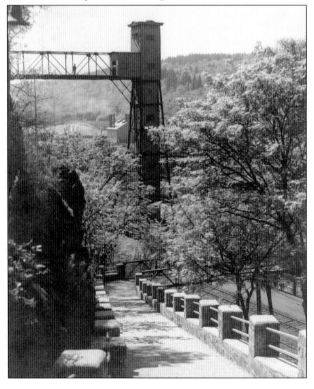

In 1912, voters authorized $12,000 to build a public elevator from the top of the bluff near Sixth Street down to Seventh Street on the river level. It was common belief that the McLoughlin Promenade extended to the elevator site. A search of the records showed the Promenade ended at Sixth Street. Sara Chase owned the property at the top of the planned elevator.

When Sara Chase refused to allow access, the city threatened to reopen an alley. With her house in the center of her property, reopening the alley would require leveling it. The state supreme court ruled the city could create a right-of-way to the elevator. Sara gave up a narrow strip of land along the bluff but refused to ride the free elevator.

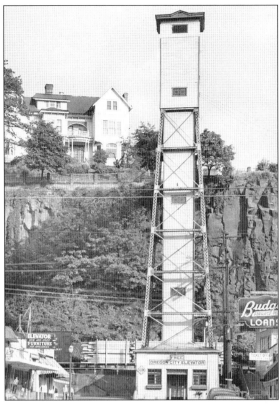

The elevator took three years to build. It was a wooden tower inside scaffolding and sat about 100 yards west of the bluff across the railroad tracks. To get to the elevator from the top, a person had to walk across an open-air catwalk that was closed on windy days. The elevator car was water powered, tapping into the city water system.

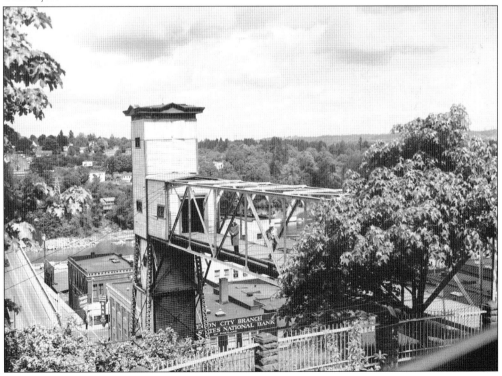

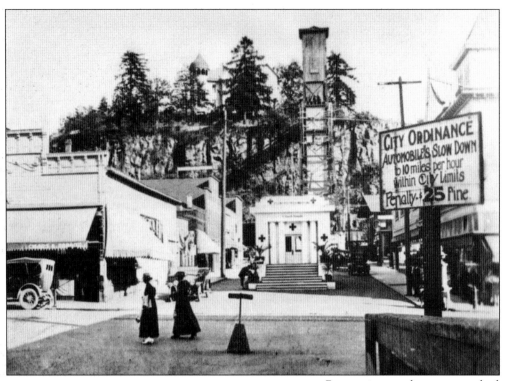

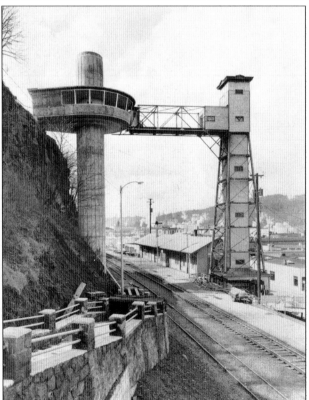

By opening a valve, water pushed the car up and by closing the valve the car would descend, taking about three minutes each way. People on the bluff could tell by a significant drop in water pressure when the elevator was ascending. In 1924, the elevator was converted to electricity, and the trip took just 30 seconds each way.

In the 1930s, during the Great Depression, Works Progress Administration crews replaced the wooden stairs to the base of the bluff. At the same time, a crew from the Public Works Administration was building the current courthouse. In 1954, the current elevator was constructed against the bluff with an underpass below the railroad tracks.

It costs Oregon City about $75,000 a year to operate North America's only vertical public street, one of only three in the world. The trip is city subsidized, but tourists are still given free passes to ride the elevator. The windows circling the top offer an outstanding view of the river level. A set of murals depicting Oregon City's history decorate the interior of the observation deck.

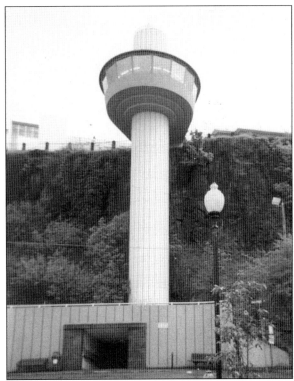

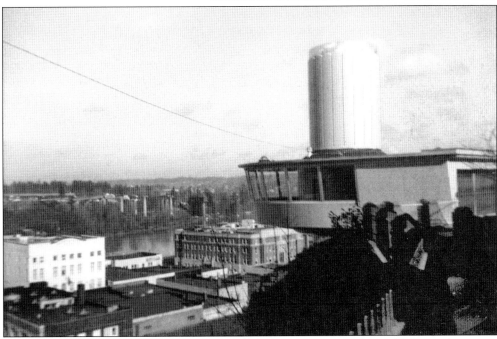

Debate continues as to how many outdoor, public elevators exist in the world. Depending upon one's definition, it is possible that there are only three vertical municipal streets. There is one in Brazil and another in Portugal. As businesses on the river level move to the Hilltop District on the third level, the importance of the public elevator wanes.

The Guynes family, consisting of father, son, and uncle, are seen on their bicycles next to the courthouse that stood on Main Street until 1936. Originally the jail was in the basement and inmates could converse with people on the street. When the newest courthouse was built in 1936, the jail was on the top floor and barbed wire was no longer needed around the courthouse.

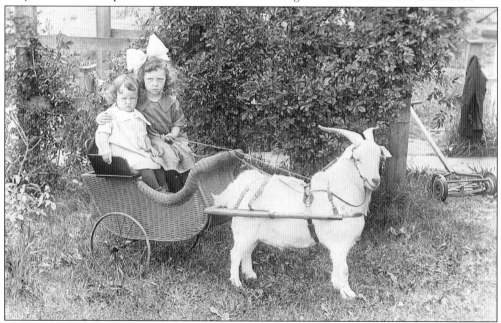

Children have always desired toys that emulate objects their parents use, such as vehicles. Today battery-powered toy vehicles carry children around neighborhoods. A century ago, children played with buggies or wagons pulled by goats. Note the newer grass-mowing convenience that would ultimately replace the goat in one of its duties.

# Six

# ENTERTAINMENT AND RECREATION

Pioneer times were rough and generally involved a lot of hard work. In the industrial era, work in the mills involved many long hours of toil. Workers needed time to be entertained, time to be amused, or just time away from work. Modern society values its "time off" for sports and recreation. Over the years, Oregon City has changed from being one of the large cities of Oregon to settling in as a smaller town in close proximity to a major metropolitan area. This change is most evident in its pattern of pastimes.

On pioneer farms, where populations were small and travel was difficult, settlers concentrated on family or community activities. Most group events, especially those that required travel, took place in the summer when roads were more passable and the weather more conducive to physical activity. Winter activities, whether on the farm or in a city, were generally held indoors.

In the cities, men could congregate after work at the local saloon to wind down before heading home. Speeches and debates at the lyceum or social club would occupy many a long winter night. Larger cities were able to attract visiting troupes of musicians, dramatic readers, plays, or recitations. Oregon City's Willamette Falls Lyceum and Debating Society was born in 1842 at Sidney Moss's Main Street Hotel. That winter, the hottest topic of debate was whether Oregon should be an independent country. After four nights of debating, the consensus was yes, unless the United States expanded to include Oregon within four years. The result of this political agitation was the Provisional Government created at Champoeg in 1843.

Home sports among family members, competitive games at school, hunting and fishing, barn raisings, quilting bees, school picnics, graduation ceremonies, and church holidays filled much of the earlier pioneer family's nonwork time. Children found the most time for entertainment.

As the state and its communities grew in population, new organized entertainment, amusements, sports, and recreational activities were created. Oregon City can boast of a few firsts in the state for some of these activities.

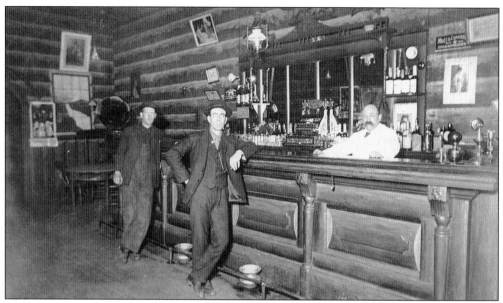

James Connor erected a distillery at Willamette Falls in 1844. The people of Oregon City ordered Sheriff Joe Meek to destroy the still. Soon there were both a temperance society and a law making it a crime to introduce, sell, or distill ardent spirits. Oregon City was dry from 1836 to 1856 and through Prohibition. Otherwise, there were saloons to quench workers' thirsts.

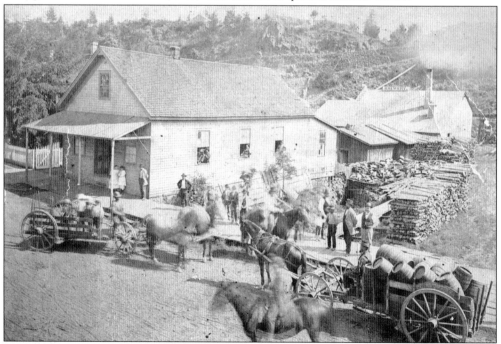

Henry Weinhard ran a brewery at Fort Vancouver before moving to Portland. He removed his major competition by purchasing the Jacob Mader's Oregon City Brewery, pictured here, tearing it down and building a distribution warehouse for his Portland-brewed product. The Weinhard Building still stands across Main Street from the courthouse. Mader's source of water, Singer Creek, is not as pure as it once was.

Among the list of Oregon City firsts is the oldest fraternal organization west of the Rockies. In 1846, a group of Master Masons met in Oregon City and petitioned the Missouri Grand Lodge for a charter. In 1848, Orrin Kellogg delivered the charter for Multnomah Lodge No. 1. The lodge meets today in their third hall. Oregon City has had numerous membership-only groups.

Fraternal organizations such as the Masons, Moose, or Eagles publicly cite their goals and intentions. The International Order of Odd Fellows work to help the poor. It is the unwritten goals of a group that set them apart. Some groups do not allow Catholics as members, others bar foreign immigrants. Ritual, pageantry, secrecy, and costumes also set them apart. Some groups become politically involved.

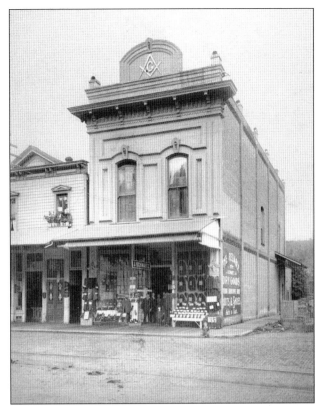

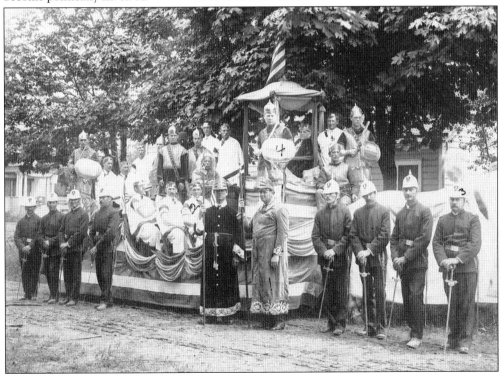

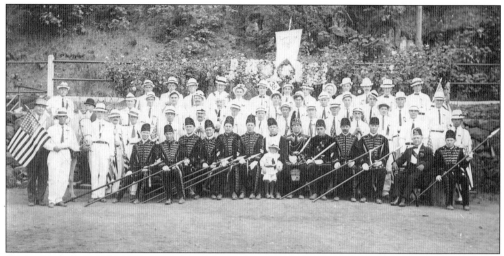

Some organizations have come and gone. The Supreme Order of the Star Spangled Banner came to Oregon in 1850 with Amory Holbrook, the first U.S. Attorney for Oregon. They died off after a local newspaper disclosed their secrets. When asked what they did, their usual answer was that they knew nothing, hence their name "Know Nothings." Holbrook went on to be grand master of the Masonic Lodge.

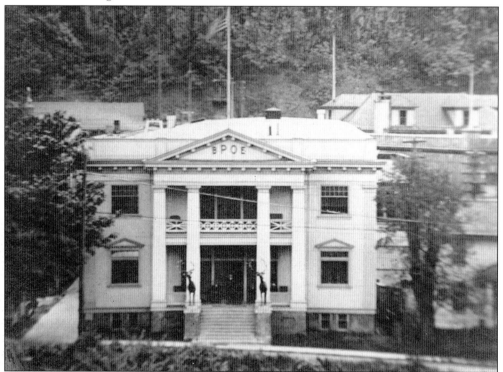

Some organizations are more socially oriented than others. Some have elaborate clubhouses so their members can meet in the privacy of their own building. Others gather in public restaurants for their weekly business meetings. Some organizations or clubs recruit only from a certain segment of the population such as business for Rotary or veterans for the Veteran's of Foreign Wars (VFW).

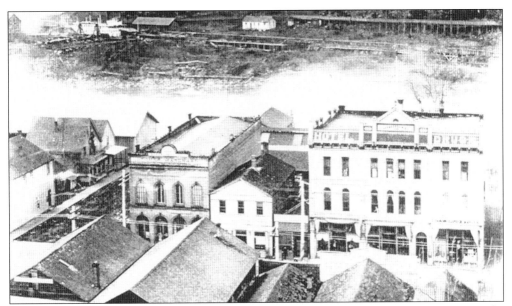

Charles W. Pope arrived in Oregon City with the 1851 Oregon Trail migration. Pope started a hardware store on Main Street, pictured left center. Pope's sons converted the second story into an auditorium, and traveling troupes would play before bejeweled matrons and patrons of the Oregon City elite on weekends. On weekdays, they moved down Main Street and did the same routines in saloons to a much different audience and reception.

In 1885, W. B. Shively and his sister Lilleon opened the Shively Opera House in the Dutch Camp District at Seventh and Madison. Patrons would arrive in carriages and climb the steps to the second-story auditorium. When moving pictures replaced gaslight dramas, the Shively became the Phantom Opera House. Oregon City High School drama classes presented plays here. The building closed in 1954 upon Lilleon's death.

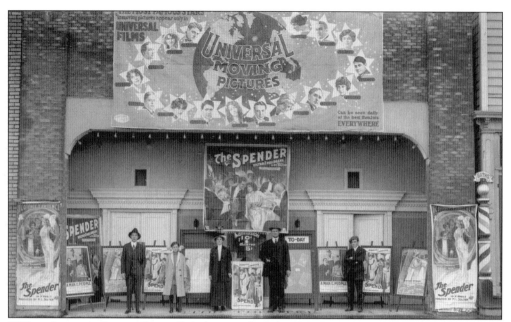

William Long, an Oregon City mill worker, watched the Shively's management of their theater. He leased a building on Main Street and had it renovated to seat 400 people in front of a permanent screen. In 1913, the Star Theater opened and ran two shows a night with piano accompaniment to the flickering movies. When talking movies appeared in 1927, the Star was wired for "all electric sound."

William Long built the Liberty Theater in 1920 next to the stately old courthouse. Movie palaces were being constructed to accommodate both movies and vaudeville. A large stage and scenery-hanging system made it a popular stop on the Pacific Coast Vaudeville Circuit. In 1927, the Liberty was also adapted for sound. The theater was closed in the 1960s and has since been torn down.

Baseball dates back to the 1840s game of rounders. The rules were much different in the 1860s than today. The first game in Oregon between two organized teams was held in Oregon City at Kelly Green on October 13, 1866. The Pioneer Base Ball Club of Portland defeated the home team Clackamas Base Ball Club of Oregon City by a score of 77 to 45 runs.

When organized baseball came to Oregon, a batter was called a hitter because there were no such things as strikeouts. The pitcher, or thrower, had to give him something to hit. A base runner could not be put out unless the ball physically touched him while he was between bases. Since the rules favored the offense, there were some very long and high-scoring games.

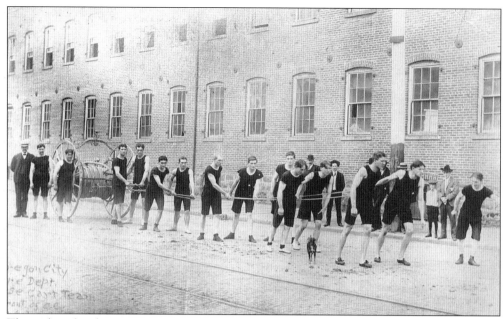

The earliest fire departments in Oregon City were volunteer organizations of workers down on Main Street. Water was pumped from the river to large tanks in two buildings on either end of town. If a fire occurred, a bell on the roof would ring and the volunteers would come running, stretching a hose from the fire hall to the fire using a hose cart.

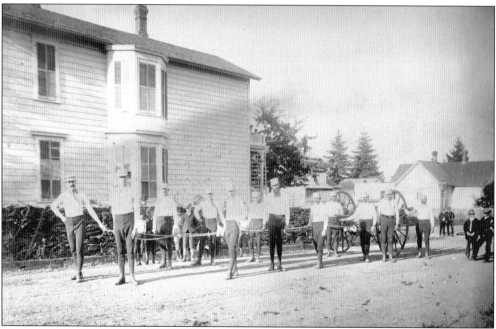

Young men with athletic ability were required. Two companies manned the Fountain Firehouse, where the Star Theater would later be built, and Cataract Firehouse across from the woolen mill. Physical fitness was taken seriously and athletic competition between the two companies was fierce. Records were kept for bragging rights.

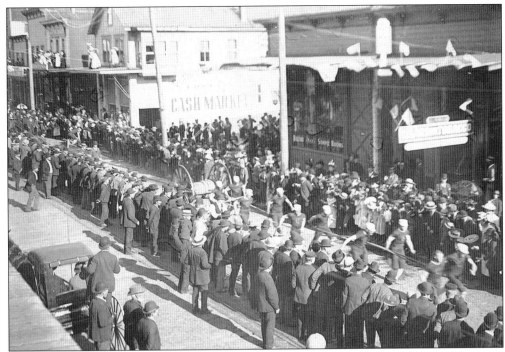

The two companies held an annual competition every Fourth of July on Main Street. They were timed to see which would be the fastest to lay hose a set distance. Crowds of onlookers lined the sidewalk and street or stood on balconies to get a good view.

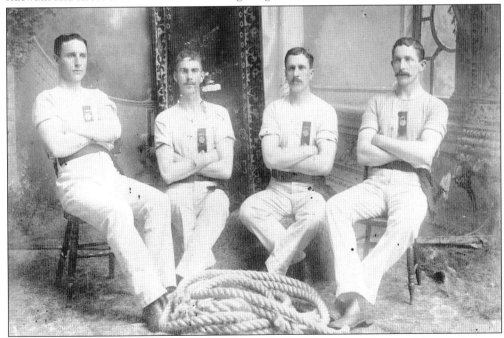

Competition was held in other sporting events as well as hose-cart races. An especially popular sport at picnics in the early 20th century was a tug-of-war, using a rope to pull another team over a center mark. A winning team received medal ribbons and would pose to have their portraits taken.

As popular as baseball was during the middle of the 19th century, football held the attention of fans from the 1890s. Oregon City had two schools with both elementary and secondary students. Barclay, named for the first school superintendent, Dr. Forbes Barclay, was the older of the two. Eastham was named for Edward Eastham, the man who electrified Portland.

The teams had their photographs and lineups printed in the local newspaper before the big game. They had uniforms with protective padding but no helmets. Mascots, usually dogs, were part of the entertainment, and the coaches communicated with trumpets to shout instructions. There were around 13 players to a team, with 11 on the field at a time.

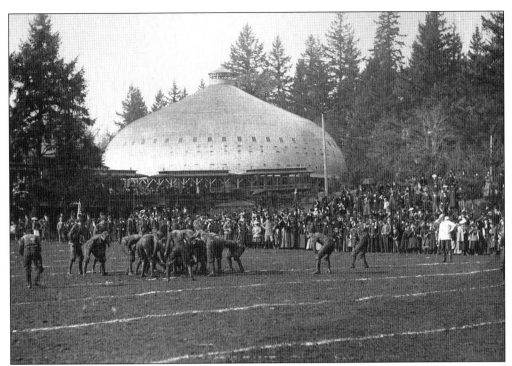

Although the rivalry between Oregon City and West Linn, originally known as West Oregon City School, is today considered the oldest in the state, the intercity Barclay-Eastham game generated far more interest at the time. Some of their games were played at the neutral, and larger, Chautauqua grounds in Gladstone, known as North Oregon City before 1889.

Chautauquas started in New York in 1874, and Gladstone was the 1894 location of the first Chautauqua held in Oregon. Every year, for 33 years, there was an annual Chautauqua Festival. In 1895, a uniquely shaped pavilion was erected to seat 3,000 persons. In 1917, the Beehive was torn down and replaced by a building that could house twice as many people.

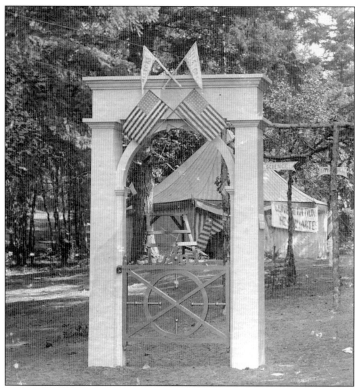

For several weeks each summer, people gathered for lectures, music, drama, and other cultural activities not usually found in small towns or rural areas. Organizers provided a combination of well-known national and local people as speakers or performers. Prominent guests locally included John Philip Sousa, Billy Sunday, William Jennings Bryan, and Joaquin Miller, the Oregon-bred "Poet of the Sierras."

Oregon City resident Eva Emery Dye, active in Abigail Scott Duniway's Suffrage Association, led in the efforts to bring Oregon its first Chautauqua in 1894 at the 70-acre Gladstone Park. She and her husband, attorney Charles Dye, convinced Gladstone founder Harvey Cross to donate the site for what was known as the Willamette Valley Chautauqua.

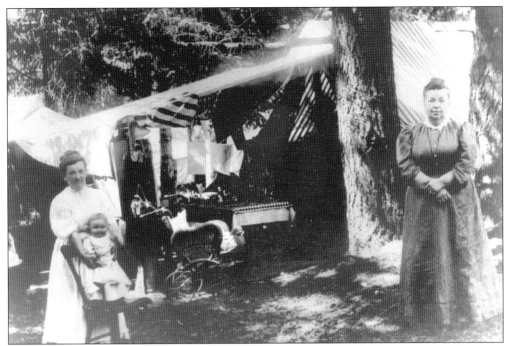

Similar to camp meetings, but far more sophisticated, Chautauquas were institutionalized systems of entertainment and instruction. Attendees would rent cabins or tent sites and spend a week there. The site was also used for sporting events and community concerts. In 1907, it hosted the first Clackamas County Fair.

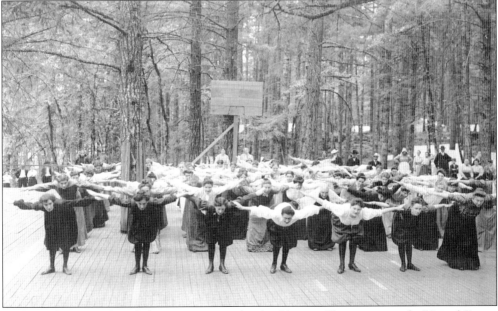

Within a few years, the Gladstone event was the third-largest Chautauqua in the United States. The pavilion was replaced in 1917 by a larger 6,000-seat building. The popularity of Chautauquas declined in the 1920s with the advent of easy transportation, moving pictures, and radio. The event folded in 1927.

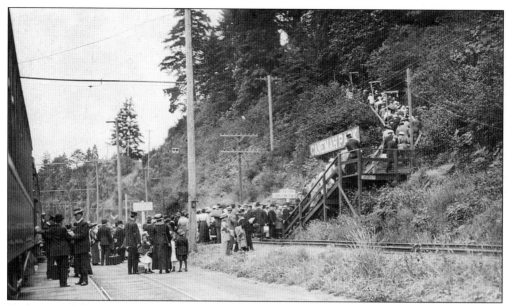

In the era of the interurban trains came the advent of amusement parks with picnic grounds. The oldest such park in Oregon was Canemah Park on the southern edge of Oregon City. The train would pass through Oregon City and stop within sight of the falls. Passengers would climb up a series of steps to get to the park grounds.

Canemah Park had a dance hall, a bandstand, several ball fields, play areas for children, and thrill rides for adults, including one of Mr. Ferris's wheels. Within two years, Portland's Oaks Park was competing with Canemah for the amusement trade. The Oaks had a floating roller-skating rink, a miniature train circling the grounds, and later a roller coaster.

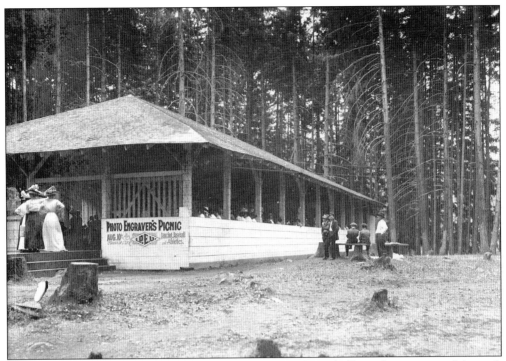

Large parties, organizations, or unions could reserve the dance hall or other sections of the park for the day. They often arrived on chartered train cars and brought their own band with them. The Interurban Company would hold special excursions on Sundays to parks such as Canemah, the Oaks, or Cazedero on the Clackamas River.

The end of interurban train travel spelled the end of Canemah Park. Today it is an empty field with hiking trails called Old Canemah Park; a newer neighborhood playground is called New Canemah Park. Cazedero Park near Estacada is also gone, but Oaks Park still thrives in Portland.

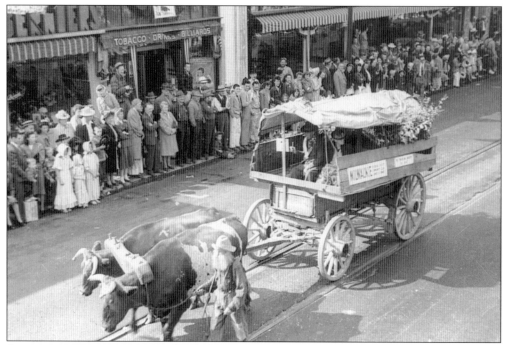

Starting in 1920, Oregon City decided to celebrate its Oregon history heritage with a parade every Fourth of July and a brief fair called Frontier Days. In 1935, the celebration was renamed Territorial Days in honor of Oregon City's history as territorial capital. A picnic at Clackamette Park, a dinner at a local lodge hall, and numerous other activities for all ages were added.

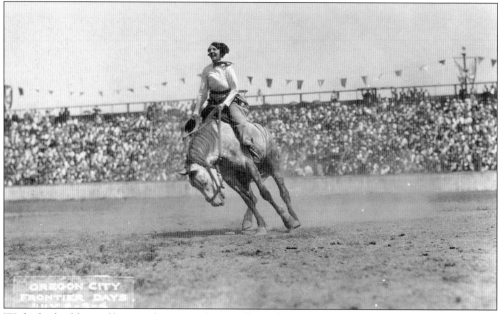

With the building of large rodeo grounds at Kelly Park, Oregon City celebrated its heritage with western cowboy events. Men and women rode wild horses or bulls, roped calves, wrestled steers, and raced around barrels. The rodeo grounds survived several floods but succumbed to old age in 1943.

Music has always been a popular form of entertainment. The first band in Oregon was an army band that arrived in 1849. There were dozens of bands, mostly brass, across Oregon in the 1850s. By far the most popular group in early Oregon came out of a small German-Dutch utopian community called Aurora Colony in 1857.

The Territorial Days, which included the last steamboat races on the Willamette, lasted into the 1970s. Pranks in Library Park included arresting citizens and charging a ransom for their release. Failed efforts to revive the celebration of Oregon City heritage included the Oregon Trail Pageant and Riverfest.

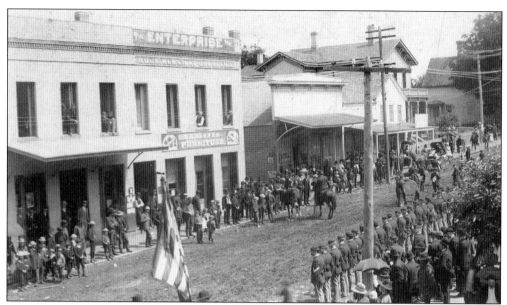

Oregon's first organized Fourth of July celebration was in 1846. It started in Oregon City with speeches and parades, followed by a steamboat trip to Champoeg. A picnic and more speeches followed. A moonlight steamboat ride home climaxed the very full day. Subsequent Independence Day celebrations involved parades, dinners, speeches, bands, games, and fireworks.

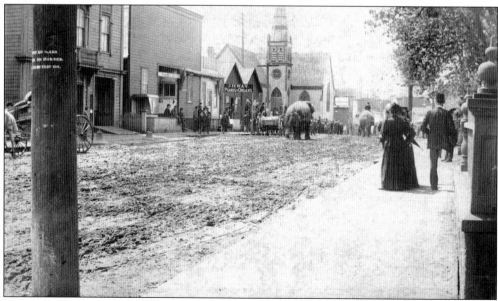

Parades have long been a popular activity. The Fourth of July, Memorial Day, patriotic events such as the Oregon City and state of Oregon Centennials, Frontier Days, Territorial Days, the Chautauqua, a circus, and sporting events were all reasons for a parade. When the circus came to town, the animals were paraded up Main Street to Canemah Park, where the large tent was erected.

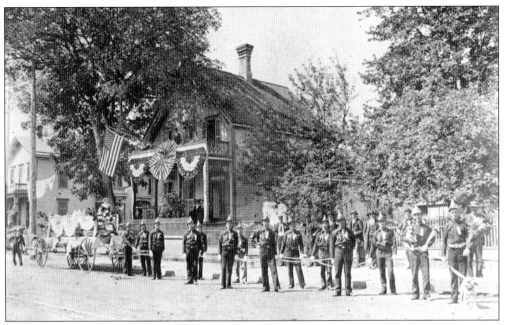

Local parades in the late 19th century included sports teams, fire department companies, equestrian units, and military bands. The hose companies were even recruited to pull neighborhood floats. Local residents along Main Street decked out their houses in patriotic bunting and flags.

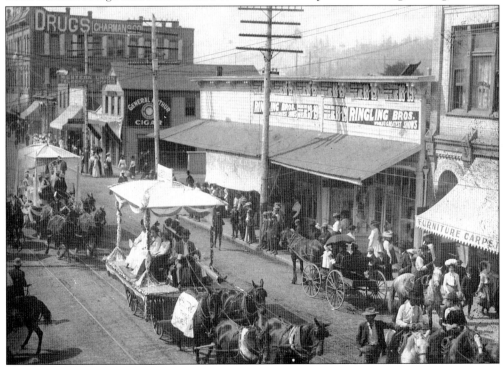

Labor Day was an opportunity for local businesses and labor unions to show pride in themselves by decorating their wagons. The parade drew smaller crowds than the Fourth of July, but any excuse to dress up in one's finery was good. Note the ads for a circus in Portland two weeks earlier.

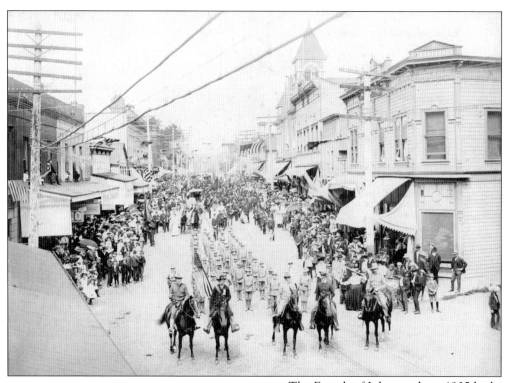

The Fourth of July parade in 1905 had a very heavy flavor of war veterans. The Oregon National Guard, including the local Oregon City infantry unit, was heavily involved in the Spanish American War and Philippines Insurrection. The fighting was still fresh in many minds. Marching units such as these Catholic boys wore military-like uniforms.

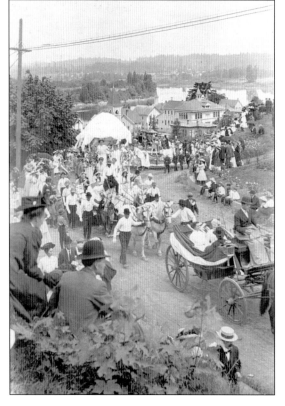

As the population built their residences on the second level, or McLoughlin District, the parades came to them. Singer Hill Road connects the two levels. In this photograph, the parade marshal, court, a band, and the Knights of Pythias float, the first of several, can be seen.

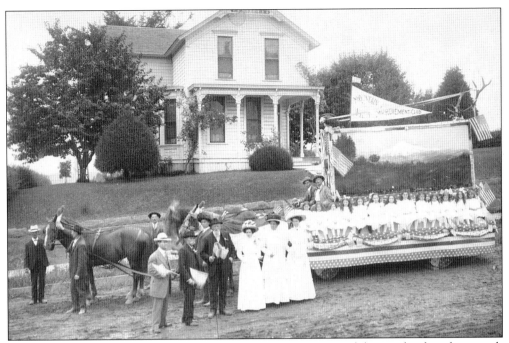

Representatives of the Mountain View Cemetery Improvement Club pose for this photograph on their way down Seventh Street to the 1910 Fourth of July parade. They are across the street from Eastham School. The painting was auctioned off for money for their cemetery improvement fund. The cemetery, Oregon City's oldest and only civic cemetery, is located on a high point of the Hilltop District.

Starting in 1936, the City of Oregon City sponsored a float in the Portland Rose Festival Parade. It was usually a heritage theme. In 1954, they honored the newly completed elevator with a float that bore its likeness. Within a couple of years, the interest in building a floral float waned and the participation ended.

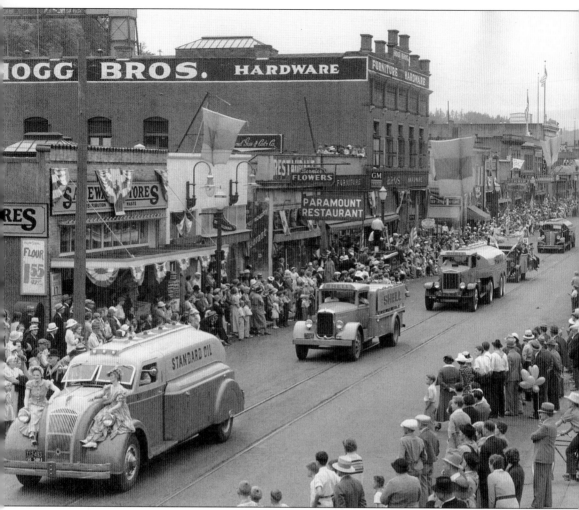

Where else but Oregon City, in 1938 during Territorial Days near the end of the Great Depression, would one see people dressed as cowboys with painted-on beards and girls in pioneer garb riding oil company trucks? Note that flour was $1.55 for a 49-pound bag and beefsteak was 17¢ a pound.

# Seven

# Clackamas County Cultural Center

Among the first Americans in the Oregon Territory were Protestant missionaries sent by the Methodist-Episcopal, Presbyterian, and Congregational churches. In bringing the word of God to the American Indians, they founded the first permanent schools in Oregon. They were successful in providing a foundation for white settlement in Oregon during a critical time of transition. They provided an incentive for people to come to Oregon and expand U.S. borders into British-controlled territory.

Forbes Barclay was born on the Shetland Islands of Scotland on Christmas Day, 1812. By 1839, he had begun a 10-year contract with the Hudson's Bay Company at Fort Vancouver as chief physician. In 1850, the Barclays moved to Oregon City. Barclay became a naturalized U.S. citizen and set up a doctor's office in his home. Being one of only a few practicing physicians in all of Oregon, he could be seen anywhere on his white horse, Snowball, or in a canoe paddled by American Indians.

Dr. John McLoughlin at Fort Vancouver set up the first classroom in the Oregon country in 1832. Oregon City received its first school in 1843, and it was the first free school in Oregon. Students did not have to be members of a congregation, be a native, or pay tuition—it was free to anyone in Oregon City. Sidney Moss picked up the tab.

The first library in Oregon was Fort Vancouver's Columbia Circulating Library in 1833. As early as 1842, the writings of local citizens were read at the Willamette Falls Pioneer Lyceum and Literary Club, or Debating Society. The provisional legislature chartered the Multnomah Circulating Library in Oregon City in 1845. The Oregon City Public Library opened in 1912, built by the people of Oregon City with some money provided by the Carnegie Foundation.

Many wordsmiths have passed through Oregon City during part of their careers. Some have gained national importance. Some lived in Oregon City toward the end of their lives, some during their prime, and Oregon City's most famous literary son, Edwin Markham, destined to be a national poet laureate, was born here.

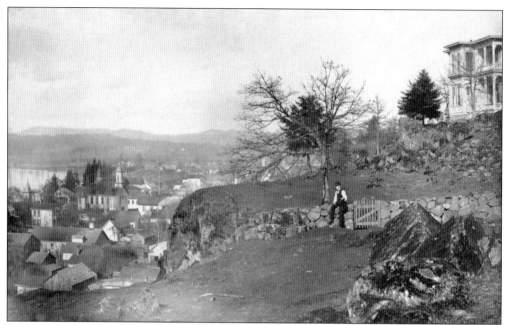

Oregon City has the oldest Protestant churches of each denomination west of the Rockies and the second-oldest Catholic church in Oregon. They all date to the 1840s and 1850s. This view was taken from the McLoughlin Promenade next to Sara Chase's residence. Below, on the river level, from left to right, the spires of the Episcopal, Catholic, and Baptist churches can be seen.

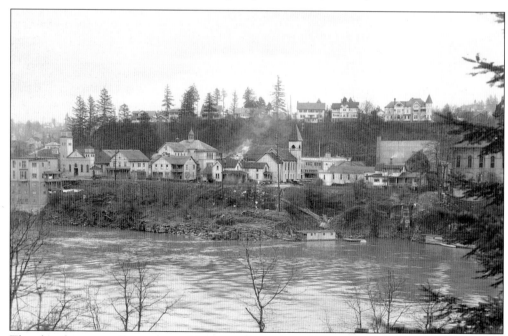

The churches were all congregated between Seventh and Eleventh Streets on Main Street or Water Avenue. Pictured, from left to right, are a river-view apartment, the Catholic church, the Catholic McLoughlin Institute school, the Baptist church, the Episcopal church, the Liberty Theater, and the old courthouse. Large residences cling to the edge of the bluff.

Alvin Waller arrived in 1840 as a missionary. He started a Methodist congregation, the oldest Protestant congregation in Oregon. The first building was a combination granary, meetinghouse, school, and church, located near the falls. One end of the large single room was a storehouse for grain. The other end had board seats stretched across stumps for meetings. In 1843, Waller constructed this first church building.

With the ever-increasing Protestant population and the promise of a flood of more immigrants, Waller constructed his church building at what is now Third and Main Streets. The building was moved down Main Street in 1856 to Seventh and Main Streets. In 1890, the original building was pushed east and a new building was erected at the Main Street site. It would survive a fire in 1919.

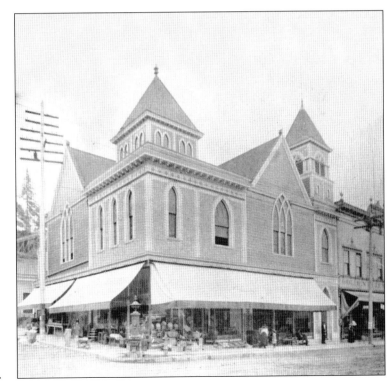

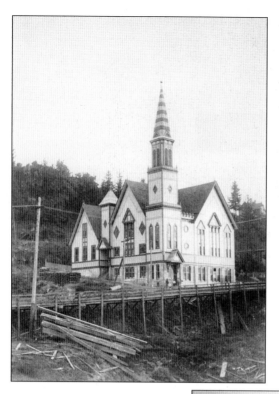

The third-oldest Protestant Church in Oregon City is the First Congregational Church. Originally located on Eleventh Street in 1850, it has been relocated twice. Their second church, seen here, came to a spectacular end in a 1923 fire. The architect of the new Atkinson Memorial Church in the McLoughlin District later designed the Oregon state capitol building.

In 1838, Abbes François Blanchet and Modeste Demers were sent to Oregon to answer the call for priests. Their first mass was held at St. Paul, in the heart of French Prairie, on January 6, 1839. In 1846, St. John the Apostle Congregation was created in Oregon City. This was Dr. McLoughlin's parish, and he was buried behind the church in 1857.

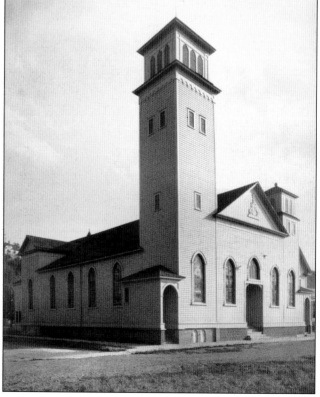

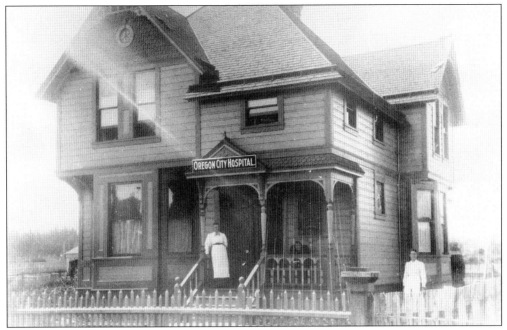

Doctors McLoughlin and Barclay were two of only a handful of medical practitioners in Oregon from the 1830s through 1860s that actually had a medical license. The concept of using private houses, owned and operated by nurses and doctors as hospitals, was popular in the 1880s. Two different houses in what is now Gladstone operated under the name Oregon City Hospital.

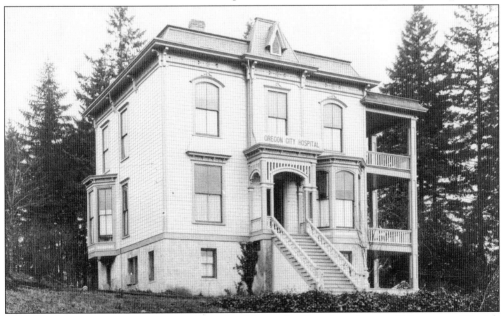

In 1911, three women, nurses recently arrived from the East, bought an old house on Dimick Street in upper Oregon City. Without the support of any male, the three women operated the third Oregon City Hospital. They advertised the "health-giving qualities of the fresh air of the heights." Tennessee Hutchinson saw her maternity hospital evolve into Willamette Falls Community Hospital.

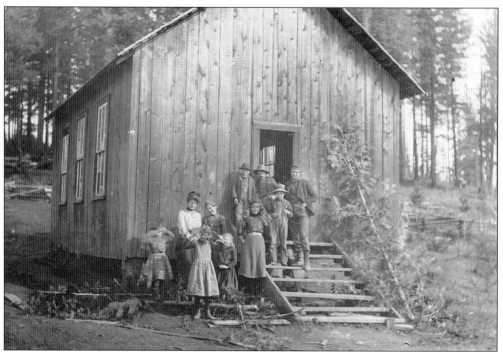

Oregon City received its first school in 1843. The school year was about six months long, from the end of harvest, all through the winter, until the beginning of next season's planting. As Oregon's population increased, more schools started. Ezra Fisher started a Baptist school in his home, which was also his church, in Oregon City in 1847. His daughter Lucy Jane Fisher was its teacher.

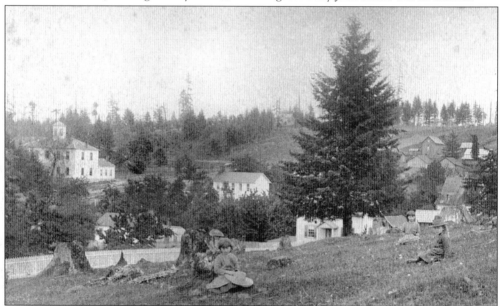

A meeting was held in Oregon City in 1849 for the purpose of organizing a college of "high moral and religious character." Dr. John McLoughlin donated a lot in town for the initial site of the Oregon City Female Seminary. It was sanctioned as Oregon City University in 1856. The Baptists moved the college to McMinnville in 1859, where it became Linfield College.

Rev. Dr. George Henry Atkinson came to Oregon City in 1848 as a Congregational missionary. He carried with him the first schoolbooks in Oregon. He was an advocate of the concept of public education as opposed to subscription or private schooling. Efforts to build a public school in Oregon City failed when the cost was determined to be $4,000 and voters would not support it.

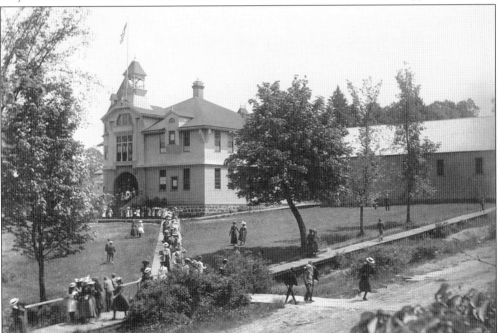

Following Atkinson-led territorial legislation, public, graded schools came to Oregon City in 1853. The old female seminary, later Oregon City University, became Barclay School, named for the first superintendent of Oregon City schools, Dr. Forbes Barclay. A majestic new building was constructed in 1886 to house first through 12th graders that attended. The current Barclay School was erected in 1950.

By 1890, the city had grown to require a second school. Eastham School was named for the banker who just a year earlier had sent electricity from Oregon City to Portland. Former independent school districts merged with Oregon City as their communities became part of the growing city. These include Canemah, Park Place, Schubel, and Redland.

In 1910, a new high school was built for grades nine through 12. That building became the junior high school in 1940 when a new high school was built. Today Oregon City has a high school that was constructed in 2002, two junior high schools, and 11 elementary schools, including one named for Dr. McLoughlin. Oregon City is also the home of Clackamas Community College.

The Oregon City Carnegie Center opened in 1912, built by the people of Oregon City with some money provided by the Carnegie Foundation. The building was a library from 1912. In 1995, the library outgrew the small building and moved up to the Hilltop district into larger, leased quarters, awaiting voter approval of a permanent location.

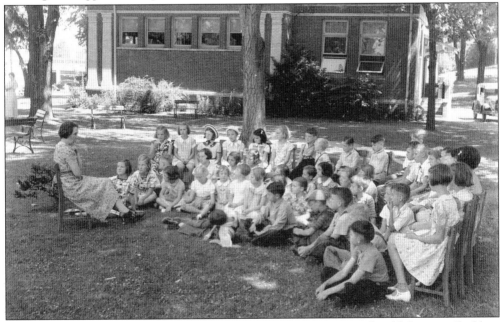

The City of Oregon City Parks and Recreation Bureau now operates the old Carnegie Building as a place to relax and meet with people. Inside are an art center, coffee shop, and children's museum. Special events are held there year-round. One popular event is the annual Concerts in the Park series. The playground and wading pool are especially popular in the summer.

Eva Emery Dye came with her husband, Charles, to live in Oregon City in 1891. Four years later, they began Oregon's first Chautauqua. Born in Illinois, she grew up listening to stories and developed a love for American history. She developed her romantic and adventurous sides and loved to read Sir Walter Scott.

Eva Dye was a regular attendee of Chautauqua events such as the Evangelist Billy Sunday's sermons. She was not content with the life of a housewife. Whenever possible, after a full day of tending to her two children, Evangeline and Everett, and housework, she would eagerly rush to write. She was happy for the rain that kept her indoors—writing.

Eva Dye wrote five books, including *Stories of Oregon*, which was for children. Asked when she first developed an interest in Oregon history, Eva answered, "I got it the very first day I arrived here. I began writing almost as soon as I reached this old and romantic city. I saw beautiful historical material lying around like nuggets and went to work right away." Within two years, she had finished *McLoughlin and Old Oregon*, which won her the title "historian of the pioneers." In *The Conquest*, she created the most endearing figures of Western literature, including Sacajawea, a teenage Indian mother heroine with a newborn on her back, guiding Lewis and Clark to Oregon. She also taught Sunday school and wrote plays such as *Ye Olde Colonial Times*, seen here, for her classes.

# ACROSS AMERICA, PEOPLE ARE DISCOVERING SOMETHING WONDERFUL. *THEIR HERITAGE.*

Arcadia Publishing is the leading local history publisher in the United States. With more than 3,000 titles in print and hundreds of new titles released every year, Arcadia has extensive specialized experience chronicling the history of communities and celebrating America's hidden stories, bringing to life the people, places, and events from the past. To discover the history of other communities across the nation, please visit:

## www.arcadiapublishing.com

Customized search tools allow you to find regional history books about the town where you grew up, the cities where your friends and family live, the town where your parents met, or even that retirement spot you've been dreaming about.